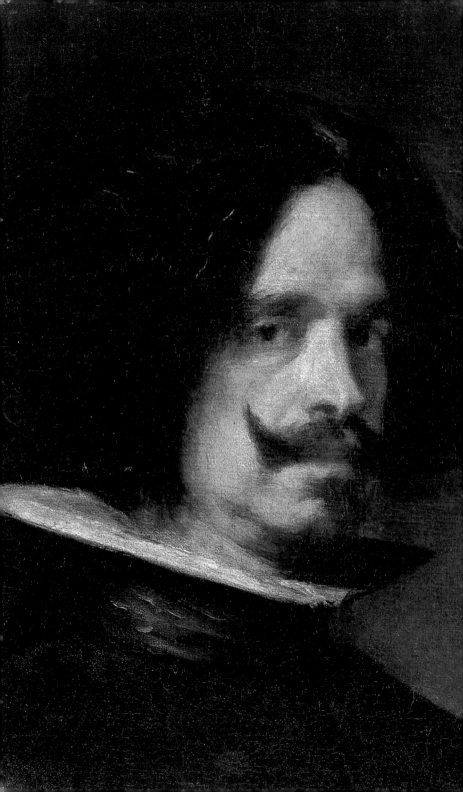

ArtBook
Velázquez

DORLING KINDERSLEY
London • New York • Sydney • Moscow
www.dk.com

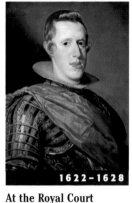

Contents

1599–1622

The early years in Seville

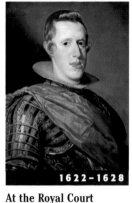

1622–1628

At the Royal Court

1651–1660

A glowing twilight

Index

How to use this book

This series presents both the life and works of each artist within the cultural, social, and political context of their time. To make the books easy to consult, they are divided into three areas, which are identifiable by side bands: yellow for the pages devoted to the life and works of the artist, light blue for the historical and cultural background, and pink for the analysis of major works. Each spread focuses on a specific theme, with an introductory text and several annotated illustrations. The index section is also illustrated and gives background information on key figures, and the location of the artist's works.

■ Page 2: *Self-Portrait*, c.1640, Museo de Bellas Artes de San Pio, Valencia.

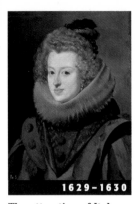

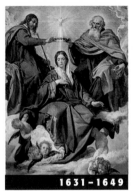

1629–1630

1631–1649

1649–1651

The attraction of Italy

The return to Spain: years of maturity

In Italy once more

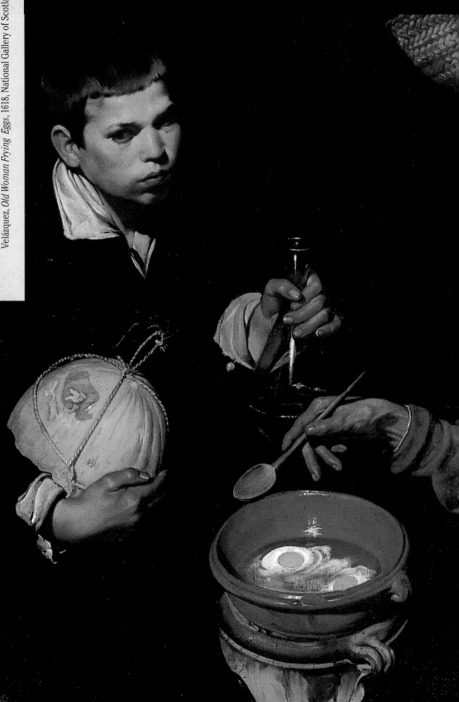

1599–1622

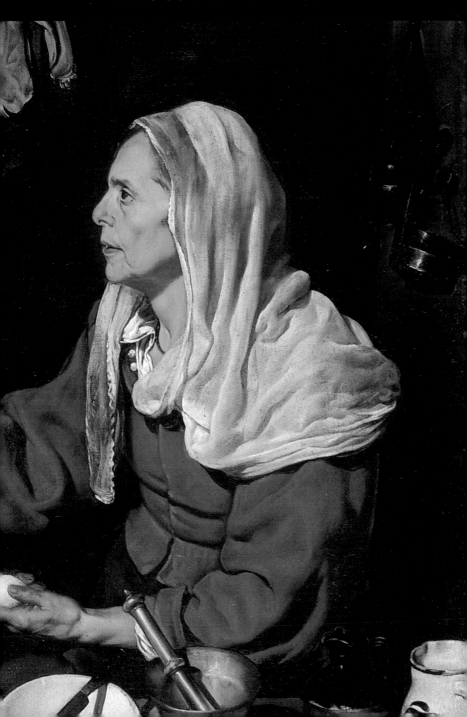

Spain: political and cultural heart of an empire

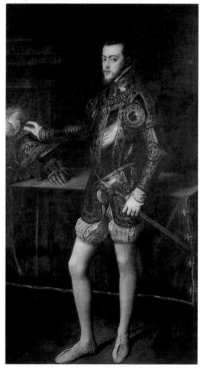

■ Titian, *Portrait of Philip II*, 1551, Museo del Prado, Madrid. Under Philip II the Spanish domains comprised the Iberian peninsula, the western Mediterranean from the Balearics to Sardinia and Sicily, the African ports of Tangier, Ceuta Melilla, and Oran, the lands of Franche-Comté, part of the Low Countries, and a large number of colonies.

At the end of the 16th century, Spain controlled an immense empire that had been created within a relatively short time. In the previous century, it was ruled by the Catholic monarchs Ferdinand of Aragon and Isabella of Castile. The kingdoms lacked political unity, and the territory was divided into counties, principalities, and signories, with their own institutions, laws, financial systems, coinage, and language. It was with the arrival of Charles V in 1516 that the two crowns were united, and to the peninsular territory was added Charles' Burgundian inheritance of Flanders and Franche-Comté. Charles became Holy Roman Emperor in 1519 and assumed rights to the Habsburg fiefs of Germany and Austria. As emperor, he occupied an extremely strong position compared with the other sovereigns of Christian Europe, and he considered himself leader of the Christian faith against the advance of the Turks in eastern Europe and the Mediterranean, and against the Lutheran heresy in the rest of Europe. With an attitude that was still relatively medieval, he aimed not only for cultural and spiritual unity among the Catholic states, but also for a cohesive political force that would take joint action against the infidels.

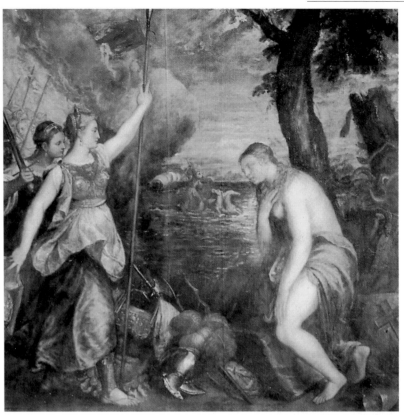

■ Titian, *Religion Succoured by Spain*, 1534–71, Museo del Prado, Madrid.

■ Right: Egidio Sadeler, *Charles V on Horseback*, 16th century, Bertarelli Collection, Milan.

■ Martin Waldseemüller, *Itinerary Map of Europe*, 1520. This road map was dedicated to Emperor Charles V, and features Spanish coats of arms. Rome is at the centre of the inverted map, signifying its importance for both the Christian faith and for political power in Europe.

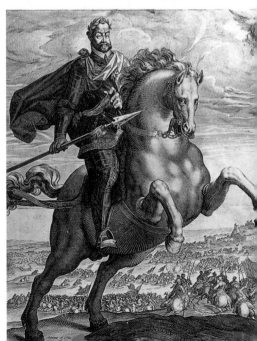

Golden Age or time of war?

■ Right: The University of Salamanca (its façade dates from 1533), the oldest in Spain, was the epitome of a Spanish university in the Golden Age; at the end of the 16th century it was attended by over eight thousand students.

■ Pereda, *The Dream of the Knight*, c.1650, Real Academia de San Fernando, Madrid. The dream was a recurrent theme in the Baroque period. This painting represents a moral allegory in which seductive worldly goods are contrasted with the brevity of existence.

The so-called *siglo de oro* or Golden Age is perhaps the most interesting in Spanish history. Normally it is taken to mean the first years of the reign of Charles V (1520s) until the Peace of Westphalia (1648) but it is sometimes extended to the end of the reign of Philip IV in 1664. Thus it spanned more than a century, during which Spain witnessed an extraordinary growth of art and literature, in spite of the decadence of the monarchy and the poverty of the people. In a country that was culturally isolated and enduring the strictures of the Inquisition, there lived, paradoxically, creative geniuses who produced masterpieces. This was the time of great painters such as El Greco, Ribera, Zurbarán, Murillo, and Velázquez, who explored religious themes as well as becoming more involved with genre and official subjects. Simultaneously, the art of the Catholic Reformation was expressed eloquently in architecture, often with theatrical and ostentatious forms. The new literature, equally dramatic in tone, was enormously successful, specifically in the form of the picaresque novel. However, behind this creative façade lay the harsh reality of the wars, which continued to ravage the country.

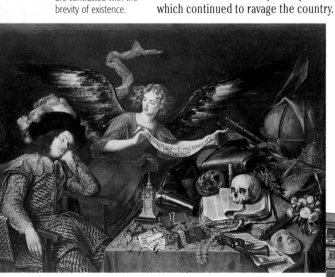

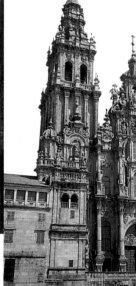

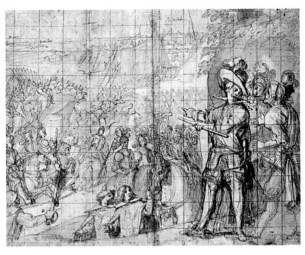

■ Vicente Carducho,
*The Capture of
Rheinfelden*, c.1634,
British Museum,
London. War raged
throughout the empire,
in spite of the many
cultural innovations.
Continual fighting
rapidly led to an
economic crisis.

■ Jusepe de Ribera,
*The Old Usurer
Woman*, 1639, Museo
del Prado, Madrid.

■ Right: Jusepe
Leonardo, *Capture
of Bisac*, detail, 1635,
Museo del Prado,
Madrid. Noblemen of
the time were usually
professional soldiers.

■ Façade of the
Obradoiro of the
cathedral of Santiago di
Compostela. Typically,
Spanish architecture
of the time was
splendidly decorative.

The recognition of crisis

Between the 15th and 16th
centuries, the so-called "arbiters"
attempted to deal with the economic
crises that Spain was experiencing.
Although they were aware of the
causes of the economic decline,
they often only proposed solutions
to very specific problems, such as
the excessive circulation of money.
Many of their theories and much of
their advice proved little more than
academic exercises.

A time of vitality and opportunity

■ Right: Velázquez, *Portrait of a Young Man*, 1622–23, Museo del Prado, Madrid. Believed to be a youthful self-portrait by Velázquez, the quality and definition of the face is particularly fine.

Diego de Silva y Velázquez was born in Seville in 1599. His father, Joao Rodriguez Silva, was of Portuguese origin; his mother, Jeronima Velázquez, came from Seville. He took his surname from his mother, according to the Portuguese style, which was also frequently used in Andalusia. As was fairly common among many families who came from Portugal and settled in Seville at the end of the 16th century, it is possible that Velázquez had distant Jewish ancestors. But his claim to the noble status of his grandparents remains unverified – later in his life he maintained that the Silvas could trace their forebears back to the legendary Aeneas Silvius, king of the city of Alba Longa. His 18th century biographer Palomino also argued this point. A more important factor in the life of Velázquez was the stimulating atmosphere into which he was born. Seville, the most populous city of Spain, was also in every sense the wealthiest, having by this time grown into a centre of cultural activity. The city was unrivalled for its vitality and versatility; and its enlightened outlook, fostered by the nobility, stemmed from its earlier environment of humanism.

■ The high tower of the Giralda, first a minaret, then the bell-tower of the Christian cathedral, dominates Seville and the surrounding plain. The architectural style of the Almohads is monumental and grandiose.

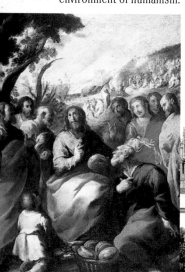

■ Left: Francisco Herrera the Elder, *Miracle of the Loaves and Fishes*, c.1640, Musée Goya, Castres. Herrera was Diego's first teacher.

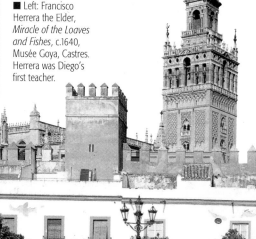

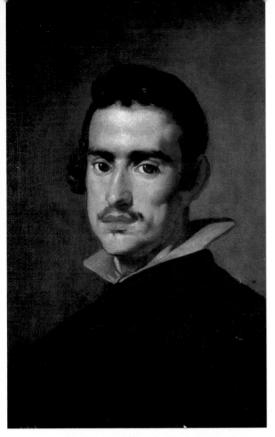

■ Diego Velázquez, the eldest of seven brothers, was baptized in the church of San Pedro in Seville, on June 6, 1599. His family had moved here, probably a generation previously, from the Portuguese town of Oporto.

■ Juan Sánchez Cotán, *Madonna Watching the Child*, early 17th century, Museo de Bellas Artes, Granada. Cotán was one of the principal artists active in Seville in the years when Velázquez was growing up. Characteristically, he employed still life in a religious context.

13

BACKGROUND

Seville: the new Rome

■ The Andalusian capital became the most important in Spain. It was the favorite residence of aristocrats, churchmen, and merchants, such as this Spanish nobleman, illustrated in the book *Ancient and Modern Costumes*, by Cesare Vecellio (1598, Bertarelli Collection, Milan).

Principal town of Roman Betica under the name of Hispalis, Seville became the capital of the kingdom of the Visigoths, and in the seventh century the Arabs settled there. At the time of the Caliphate it was second only to Córdoba, and already by the tenth century it was the most prosperous city in Andalusia. The city, rising up on the banks of the Gualdalquivir, reached its peak in the 11th century as capital of the Abbasids and later of the Almohads, who built numerous splendid buildings and a new mosque. During this period it became the focal point of Andalusian, and indeed all Spanish, art and culture. After the reconquest of 1248 by Ferdinand III of Castile, its fortunes prospered anew and, in the 16th century, it was transformed into the most heavily populated and wealthiest city in Spain, due to the trade monopoly with America granted by the Catholic kings. This privilege, and the establishment of business houses, attracted merchants from all over Europe, particularly Flanders and Italy – countries noted for their commercial enterprise and cultural vitality. At the beginning of the 17th century Seville retained its position as the economic and maritime capital of Spain: it was also a great Baroque city with a cultivated elite who encouraged local art and literature.

■ Below: Juan Martínez Montañés *The Immaculate Conception*, known as *La Cieguecita*, 1629, Seville Cathedral. This is a fine example of Sevillian religious sculpture.

■ Right: The Alcázar of Seville. The splendid Arab heritage of Seville was embellished by the 17th-century artists, who continued to decorate the commercial capital in the Baroque style.

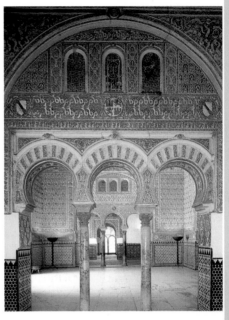

■ Christopher Columbus, in an engraving by Aliprando Capriolo, from the end of the 16th century, Bertarelli Collection, Milan. The Spanish expedition that culminated in the discovery of America departed from Seville.

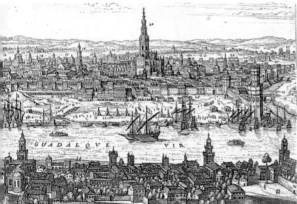

GUADALQVIVIR

■ Following the discovery of the New World, ancient Hispalis experienced a long period of economic prosperity that would only begin to decline during the reign of Philip IV.

The masters: Francisco Herrera and Francisco Pacheco

EL PARNASO
ESPAÑOL
PINTORESCO LAUREADO.

TOMO TERCERO.

CON LAS VIDAS DE LOS
Pintores, y Estatuarios Eminentes
Españoles,

QVE CON SVS HEROYCAS OBRAS
han ilustrado la Nacion.

Y DE AQUELLOS ESTRANGEROS
Iluftres, que han concorrido en eftas
Provincias,

Y LAS HAN ENRIQVECIDO CON SVS
Eminentes Obras.

GRADUADOS SEGUN LA SERIE
de el tiempo , en que cada vno
florecio:

PARA ETERNIZAR LA MEMORIA,
que tan juftamente fe vinculato en la pof-
teridad con fublimes , y remontados
afpiritus.

EN MADRID Año de 1724.

The apprenticeship of Velázquez began at the age of ten with Francisco Herrera the Elder, described by Palomino as "a strict man, without charity", albeit with artistic talent and taste. However, his inflexible character drove the young Velázquez to turn to Francisco Pacheco, with whom he formalized his apprenticeship contract in 1610. A contract of this type lasted from four to six years, during which the apprentice lodged at the workshop of his master, who provided him with food and clothes. Pacheco was a mediocre painter but a rigorous teacher; he conceived painting as a high artistic form, and his home, frequented by men of culture, was a very stimulating place. In the spring of 1617 Velázquez passed the compulsory examination required for the practice of painting. The guild examiners (Pacheco and Juan de Uceda), in applying for the licence which normally had local restrictions, requested, unusually, that the right to practise be extended to the entire kingdom. Now Velázquez was ready to open his own workshop and, as a master, to form contracts of apprenticeship and collaborations with other painters.

■ Frontispiece to the third volume of Antonio Palomino's book, which was devoted to the lives of Spanish artists.

■ Francisco Herrera the Elder, *Triumph of Saint Hermengild*, 1624, Museo de Bellas Artes, Seville. Herrera taught Diego the principles of color, realism, and chiaroscuro.

■ Francisco Pacheco, *St John at Patmos*, British Museum, London. Velázquez was inspired by this drawing for his *St John,* shown far right.

Sources for the history of Spanish art

The principal literary source for the history of Spanish art was a weighty 18th-century text written by Antonio Palomino, painter to the court of Philip V. The three-volume work, inspired by Vasari, dealt with painting, architecture, sculpture, and artists' lives, with the declared intention of providing Spain with the means to compete, artistically, with the rest of Europe. Making reference to various authors who had preceded him with similar undertakings (such as Lázaro Diaz), to manuscripts subsequently lost, and to a series of oral accounts of the tradition of Spanish workshops, Palomino's work was enormously successful from the year of its publication in 1724.

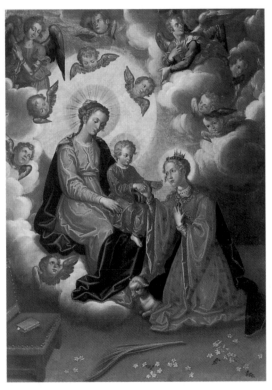

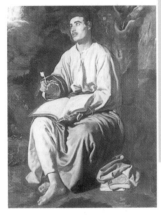

■ Velázquez, *St John the Evangelist on Patmos*, c.1618, National Gallery, London. The composition of this work is derived from Pacheco, but in his figurative painting and choice of colors the young Velázquez has already surpassed his teacher.

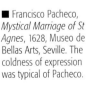

■ Francisco Pacheco, *Mystical Marriage of St Agnes*, 1628, Museo de Bellas Arts, Seville. The coldness of expression was typical of Pacheco.

■ Velázquez, *Portrait of Francisco Pacheco*, c.1618, Museo del Prado, Madrid. This bust of his master is finely executed by Velázquez. The ruffed collar is particularly detailed.

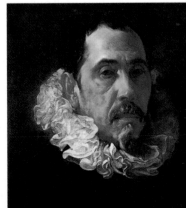

The *bodegón*: symbol and reality

The cultural climate of Spain during the Golden Age was characterized by an intellectual liveliness and wit, and a fashion for puzzles and rebuses, which painters used to conceal hidden meanings in their works. The *bodegón* (literally "tavern"), or still life, was very popular in 17th-century Spanish society as a secular genre of painting. Often, however, it hid a symbolic meaning within its domestic subject-matter. The first examples in the 15th century went back to Flemish tradition. In the following century, in Toledo, there emerged a school of painters who concentrated on still life themes, instead of religious pictures. Fruit symbolized, initially, the senses of sight, hearing, touch, and taste, and later also came to signify the virtues and vices. The preference for flowers and fruits was inherited from the Andalusian Moors, whose poets celebrated orchards and gardens, comparing the beauty of flowers and fruit to that of women and children. The *bodegón* might also contain a deeper moral lesson by the insertion of skulls, water-clocks, and other objects alluding to the passage of time, reminding the spectator of their mortality and the transience of earthly existence.

■ Right: Juan de Valdés Leal, *Hieroglyph of Time*, c.1672, Ospedale della Carità, Seville.

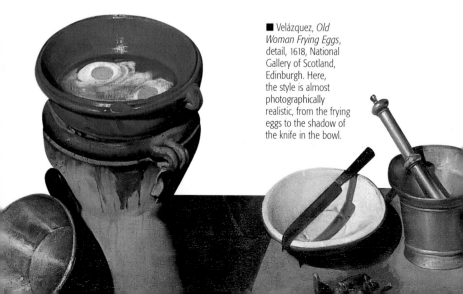

■ Velázquez, *Old Woman Frying Eggs*, detail, 1618, National Gallery of Scotland, Edinburgh. Here, the style is almost photographically realistic, from the frying eggs to the shadow of the knife in the bowl.

■ Juan Sánchez Cotán, *Still Life*, c.1600, Museum of Art, San Diego. The fruit has a double aspect – decorative and symbolic – suggesting that it was meant to have a spiritual appeal. Among the painters of *bodegones*, Cotán was the most famous.

■ Juan de Valdés Leal, *Hieroglyph of Death*, 1672, Ospedale della Carità, Seville.

■ Francisco Zurbarán, *Still Life with Vases*, Museu d'Art de Catalunya, Barcelona. Here, simplicity and harmony are derived from the ordinariness of the objects and the purity of the forms.

19

The Waterseller

This painting (Wellington Museum, Apsley House, London) was donated in 1623 to the Sevillian canon Juan de Fonseca. An early *bodegón* masterpiece, as much emphasis is placed on the jugs and water glass as the three figures.

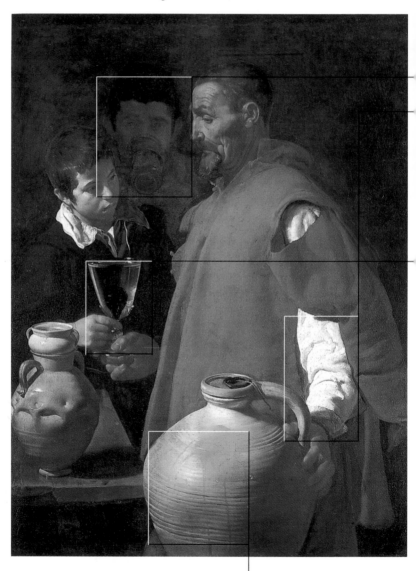

■ The elderly waterseller hands a glass of water to a young boy while the man behind them drinks from a tumbler; it has been suggested that this could be a symbol of thirst or, in the allegory of the three ages, of mature man attaining knowledge.

■ From the tattered cloak of the old man, with its ripped sleeve, emerges his arm, draped in a pure white shirt: this suggests a level of dignity in the otherwise modest figure. The arm, resting on the pitcher of water, projects towards the spectator.

■ The crystal goblet offered by the waterseller reveals, through the transparency of the liquid, a fig, perhaps used to scent the water or to add "health-giving virtues" to it.

■ Close inspection of the side of the large water pitcher reveals drops of water, painted in great detail, running down the spiral walls.

1599–1622

A new family
and early works

■ Velázquez, *St John the Evangelist on Patmos*, detail, c.1618, National Gallery, London. The face of St John, in the companion painting to *The Immaculate Conception*, has been recognized as the artist's self-portrait.

Having passed the obligatory guild examination, and now ranked as an accredited artist of Seville, in 1618 Velázquez married Juana Pacheco. She was the daughter of his teacher, who, seeing that his young pupil was talented and industrious, wished to link him definitively to his workshop. The possibilities now open to Velázquez were the same as those available to all successful artists of the time: commissions, principally from the Church, which required religious subjects and devotional pictures, portraits, monastic cycles, and still lifes. However, a new interest in the study of naturalism was emerging, which was becoming accepted by the Church, who welcomed it as a means of increasing awareness of religious truth and of opposing the intellectual abstractions of the Protestant Reformation. During this time, Velázquez became more skilful in the representation of reality, the handling of dimension and volume, and the use of different materials to convey the illusion of chiaroscuro through his still lifes.

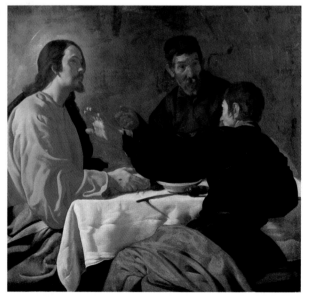

■ Velázquez, *The Supper at Emmaus*, c.1620, Metropolitan Museum of Art, New York. In his early works, sacred subjects played a fundamental role. This scene is similar to typical paintings by Zurbarán, and also reveals the stylistic influence of his first teacher, Francisco Herrera the Elder.

■ Velázquez has possibly included Pacheco, his teacher, in *The Adoration* (detail, 1619, Madrid, Museo del Prado), appearing as the kneeling king.

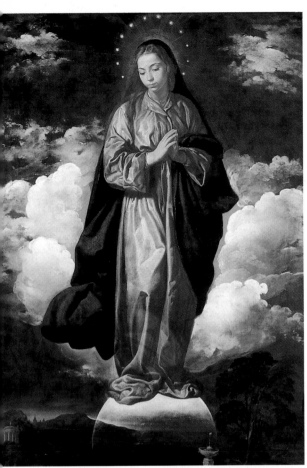

■ Velázquez, *The Immaculate Conception*, 1618, National Gallery, London. This devotional work was probably painted just before the artist's marriage to Juana Pacheco, who modelled for the face of the Virgin. Velázquez followed iconographical tradition: on the earthly globe, Mary remains untouched by the serpent, symbol of sin.

■ Below: *Adoration of the Magi*, (detail, 1619, Museo del Prado, Madrid). In his studies, Velázquez turned to members of his own family as models. Here Juana, his wife, and their son Francisca whom she holds on her lap, appear as Mary and Jesus.

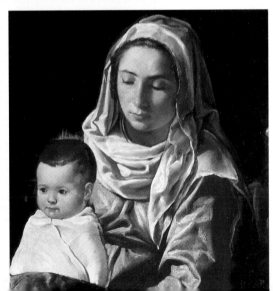

1599–1622

The Adoration of the Magi

Probably painted for the Society of Jesus in 1619, this work (Museo del Prado, Madrid) illustrates Velázquez' different use of light, color, and texture when painting ordinary mortals and divine figures.

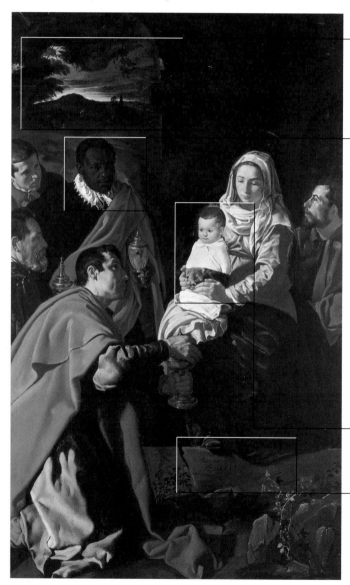

■ The detail of the open landscape against the twilight sky, in a masterly effect of back lighting, just reveals the wall of a hut. It anticipates Velázquez' accomplished landscapes, but is tenebrist in style.

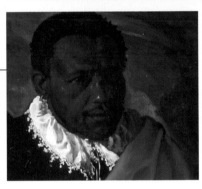

■ Above: Subtle contrasts of color emphasize the mortal kings' features – Balthasar's bright white lace collar catches the viewer's eye.

■ The Christ Child is modelled by the artist's daughter Francisca. The divine couple are bathed in a glowing light that illuminates their features.

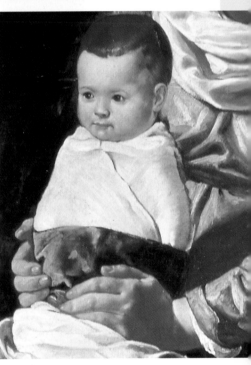

■ Appearing on the stone that forms the base of the group with the Virgin and Child, is the date 1619, the year after Velázquez' marriage to Juana, and the same year in which his daughter Francisca was baptized.

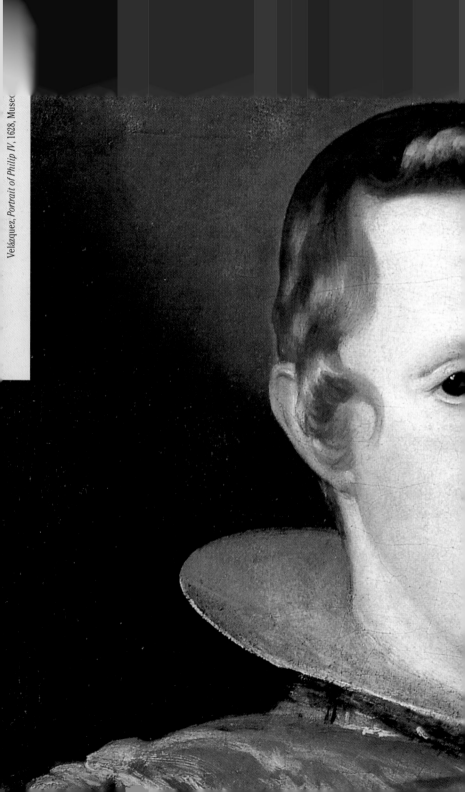

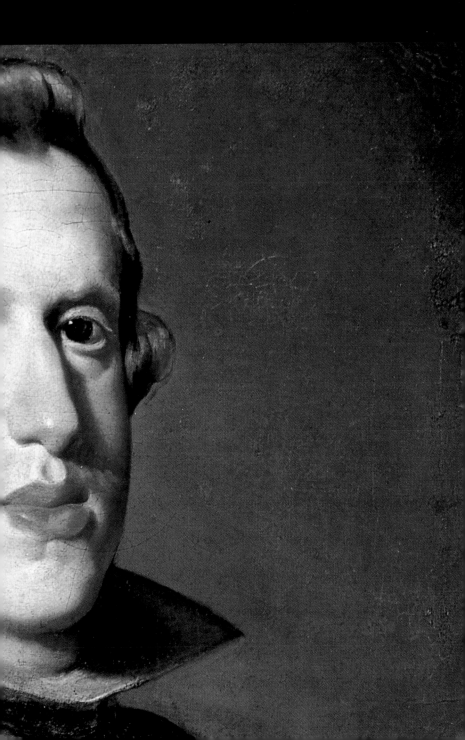

Painter to the king

■ Right: Velázquez, *The Poet Luis de Góngora*, 1622, Museum of Fine Arts, Boston. This was the only Velázquez painting dating from the first trip to Madrid. Pacheco reported that it was "much praised", and it earned the young artist a reputation among Madrid society.

O n the death of King Philip III, his successor, Philip IV, appointed as his prime minister the count-duke Gaspar Guzmán de Olivares, who was keen to encourage the artists and writers of Seville, and who probably knew of Velázquez' work. On the recommendation of Pacheco, Velázquez made his first journey to Madrid in 1622, mainly to see the Escorial and its great display of masterpieces. Don Juan de Fonseca, once a canon from Seville and now chaplain to the king, failed in his attempt to get for the young Velázquez an opportunity to paint a member of the royal family, and instead he made his mark with a portrait of the famous poet Don Luis de Gongora. A year later he was summoned back to Madrid by the count-duke. On this occasion Velázquez did indeed paint a portrait of the king, who was sufficiently impressed to appoint him, soon afterwards, to the post of court painter. Velázquez then moved with his family to Madrid, living in the royal palace, where he had his own workshop and where he led the life of a court dignitary.

■ Below: El Greco, *St Ildefonso Receiving the Chasuble*, 1585-87, Toledo Cathedral. The first visit to court provided Velázquez with the opportunity to get to know the works of El Greco.

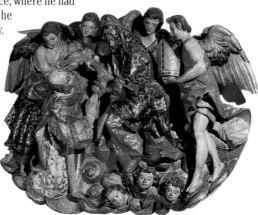

■ Velázquez, *St Ildefonso Receiving the Chasuble from the Virgin*, 1623, Museo de Bellas Artes, Seville. Velázquez' debt to El Greco is evident here.

■ Right: El Greco, *Trinity*, 1577–79, Museo del Prado, Madrid. The typically angelic figures of El Greco were later to be emulated by Velázquez.

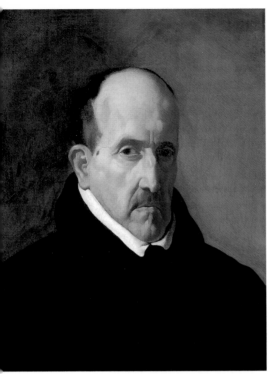

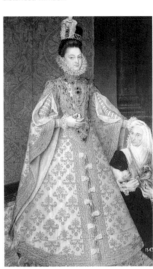

■ Alonso Sanchez Coello, *Portrait of the Infanta Isabel Eugenia*, 1580, Museo del Prado, Madrid. This was a traditional court portrait, and a type from which Velázquez soon distanced himself.

■ Velázquez, *Gaspar de Guzmán, Count-Duke de Olivares*, 1624, Museu de Arte, São Paulo, Brazil.

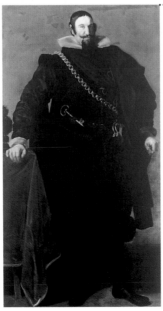

King, prime minister, and government

Philip II, a strong leader, had presided over a centralized government. This policy, whereby most officials were deprived of initiative and the power of decision-making, was not continued under his successor Philip III. He, in fact, entrusted the direction of public affairs to a prime minister, who as a close friend of the king was able to intervene directly in affairs of state. The monarch also depended upon his *criados*; trusted men in his private service who carried out the kingdom's administrative functions. Philip IV, too, handed over much of his political power to the count-duke of Olivares, and, surrounded at court by the Spanish nobility, could then devote more time to art and culture.

Madrid, the new capital

Founded in the ninth century by the Emir Mohammed I as a defence to protect Toledo, the town that was to become Madrid was liberated in 1083 from Muslim rule by Alfonso VI who conceded lands and privileges to the inhabitants. Under Henry VI of Castile (1454–74), with new parishes, the town's commercial importance grew and the population rose to five thousand, although it did not yet rival centres such as Seville, Valladolid, and Toledo for cultural activity. Only in 1561 did Philip II decide to transfer the court there, principally for its geographical position: situated at a height of 655 metres (2150 feet) in the middle of the Meseta plateau, its dry air was ideal for the delicate health of the queen, Elizabeth of Valois. Another reason to hold the court there was the need to provide a stable base for the central offices of administration, which followed the court whenever it travelled. For the expanding bureaucracy of officials, servants, and archivists, such moves had by now become extremely difficult.

■ Pedro de Teixetra, *The Alcázar Plaza*, City Archive, Madrid. The ancient Arab alcázar (palace) was neglected by Philip II, who preferred to concentrate effort and money on the building of the Escorial monastery.

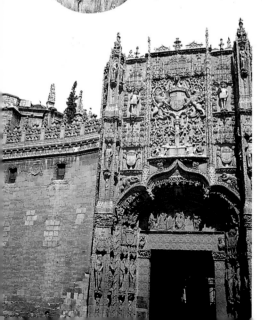

■ Above left: Drawing from Antonio Campo, *History of the Lives...*, 1642, Bertarelli Collection, Milan. For the sake of his third wife, Elizabeth of Valois, Philip II transferred his court permanently to Madrid.

■ Left: College of St Gregory, Valladolid. In the 13th century this was the favorite city of the kings of Castile, who often set up court here. The future king Philip IV was born here in 1605.

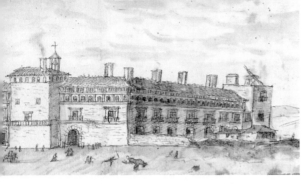

■ Right: El Greco, *View of Toledo*, c.1600, Metropolitan Museum of Art, New York. The Catholic kings had splendid buildings erected in Toledo.

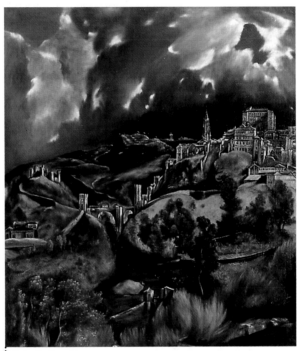

The other capital

Before Philip II established the capital at Madrid, the court moved from city to city. The historical cities of Toledo and Valladolid were often used. Toledo, for three centuries capital of the Visigoth kings, was in the eighth century occupied by the Muslims and became an independent kingdom in 1012. Reconquered by Alfonso VI of Castile in 1085, it was granted the title of imperial city by Alfonso VII. Valladolid gained an important role in the 11th century when it received a municipal charter from Alfonso VI. It had often been the royal seat of the kings of Castile since the 13th century, and in 1601 Philip III decided to return, establishing the administration there. However, the seat of government was finally transferred to Madrid in 1621 by order of Philip IV.

31

Literary triumphs of 17th-century Spain

There was a particularly concentrated output of innovative literature in the period known as the Golden Age. This included lyric and epic poetry, drama, and secular and religious prose (St Teresa of Jesus, St John of the Cross). Luis de Góngora, with his complex and often obscure poetry, full of hyperbole, was one of those who sought to create a new poetic language. This style was further developed by the great satirical writer Quevedo, author of the *Sueños*, whose subtlety of thought was expressed through word-play. The past heroic romances were challenged by the emergence of pastoral and Moorish romances, but above all by the picaresque novel. In the 17th century, too, the Baroque theatre, dominated by the Sevillian and Valencian schools, assumed a national character; and the great Lope de Vega, with a vast output of almost two thousand works, encapsulated and defined the poetry and drama of the century in all its guises. On his death, a period of political decline coincided with one in literature: only the theatre continued to prosper with Pedro de Calderón de la Barca.

■ The university of Alcalá di Henares saw the publication in 1517 of the magnum opus of the Renaissance, the *Complutensian Polyglot Bible*.

■ Right: the popular drama of Lope de Vega swept the country at the end of the 16th century: later, the more cultivated plays of Calderón emerged, classical in form and moralizing in tone.

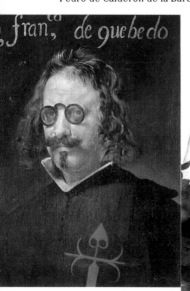

■ *Francisco Gómez de Quevedo y Villegas*, a copy by Velázquez, Instituto Valencia de Don Juan, Madrid.

■ Right: Honoré Daumier, *Don Quixote and Sancho Panza Find the Dead Mule*, 1867, Musée du Louvre, Paris. The many different forms of romance, from the heroic to the pastoral, the sentimental to the picaresque, fuse in Cervantes' *Don Quixote*: a wholly original synthesis of the grotesque, the farcical, and the sublime.

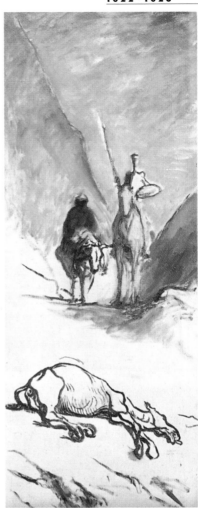

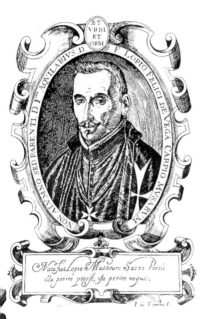

The picaresque novel

Towards the end of the reign of Charles V, the publication of the *Life of Lazarillo de Tormes* by an unknown author pointed the way to the genre of the picaresque novel, a much more realistic form compared to the idealistic fantasies of the hitherto ubiquitous heroic romances. The protagonists of these novels were the *picaros* (beggars, vagabonds, and rogues), symbols of the socio-economic decline of Spain at the time. The tone of the narrative is comic yet liberal, showing life at the lowest levels of society. After a series of weak imitations published in the 16th century, the genre received fresh impetus with Quevedo and Cervantes, and throughout Spanish literature the picaresque style won acclaim.

Portrait of the Infante Don Carlos

This portrait (Museo del Prado, Madrid) was completed between 1626 and 1627 when the king's brother was about twenty years of age. Don Carlos is painted in an elegant pose, more relaxed than is customary for a sovereign.

■ The hand that nonchalantly holds the loose glove by its index finger is beautifully drawn. The delicacy of the complexion, contrasted with the dark background, is accentuated by the detail of the slightly curved little finger.

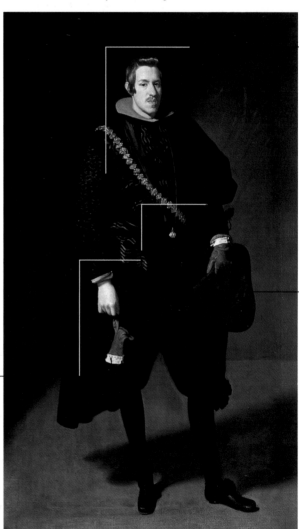

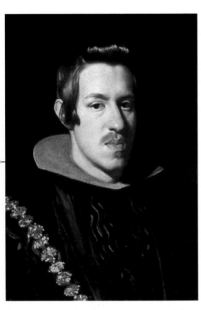

 The resemblance to other members of the royal family is evident in the portrait of the king's other brother, the cardinal Infante Don Fernando, completed by 1636 (detail, below, Museo del Prado, Madrid). Don Fernando must have been about the same age as Don Carlos when painted by Velázquez, but this portrait is much more informal, since this work is less official than the other.

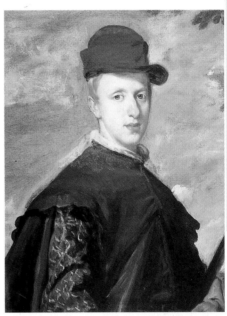

■ An accessory to fashion, which appeared in the reign of Philip IV, was the broad ruffed collar of Flemish origin, held in place and stiffened with starch. The handling of this detail by Velázquez is light and confident, as is the expressive face and elegant hairstyle.

■ The gold fleece, hanging from a dark ribbon matching the color of the clothes, is attached to a superb gold chain slung over the shoulder, which emphasizes the dignity of the royal subject.

■ Velázquez, *Portrait of Philip IV*, 1628, Museo del Prado, Madrid. Compared with the relaxed portrait of the Infante, the details of the king and his clothing reveal a less flexible treatment by the artist.

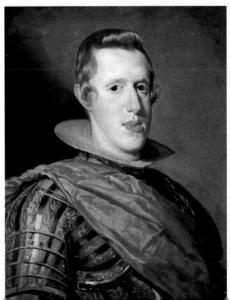

The official portrait

In the course of the Golden Age, the official portrait — usually of monarchs and high-ranking dignitaries — became an increasingly important genre. Portraits, as lifelike representations of the subjects, were often thought of as substitutes for the sitters themselves — pictures of nobility were treated with respect and reverence. Engaged couples often saw one another only in their respective portraits, and marriages could even be celebrated by proxy on the basis of these images. The genre had a secular tradition in European courts and it originated from coins, on which the emperor, for example, was depicted in profile. During the Renaissance, the frontal portrait became more common and, as the 17th century progressed, it was consolidated and developed by the inclusion of symbolic elements, which served to reinforce the power of the image. The pose was never casual, the subject never portrayed in a private attitude, but was provided with attributes calculated to emphasize the high position he or she occupied in society. In Italy and Flanders, complex symbols and allegories were adopted, whereas in Spain objects that needed little interpretation, such as clothes, accessories, or furniture, were preferred. Among these, for instance, might be a small table against which the standing subject would lean: a sign of majesty or justice. Towards the end of the century, items such as clocks might be added, signifying the passage of time and the mortality of the individual.

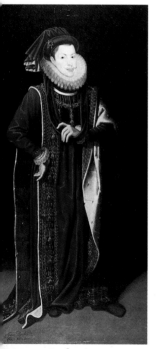

■ Juan Pantoja de la Cruz, *Portrait of Philip III*, 1608, Musée Goya, Castres. In this image of royalty, the monarch wears the uniform of the Grand Master of the Golden Fleece. The 15th-century costume is faithfully reproduced, down to the insignia of the collar.

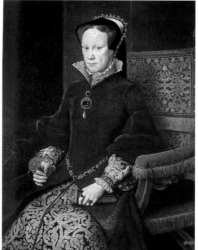

■ Anton Mor van Dashorst, *Mary Tudor, Queen of England*, 1554, Museo del Prado, Madrid. Anton Mor van Dashorst worked at a number of European courts, and was noted for his remarkably naturalistic portraits, such as this of the second wife of Philip II.

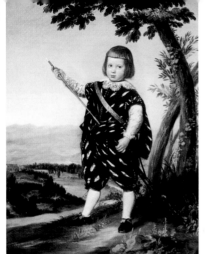

■ Alonso Cano, *The Infante Baltasar Carlos*, c.1634, Szépmüvészeti Museum, Budapest. Young members of the royal family were also painted, such as the young heir of Philip IV, shown here.

■ Below: Titian, *Portrait of Isabella of Portugal*, 1548, Museo del Prado, Madrid. Titian worked from a portrait of Isabella to paint his own portrait of her ten years after her death.

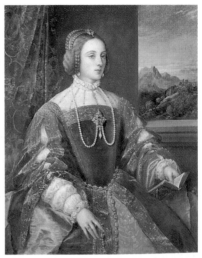

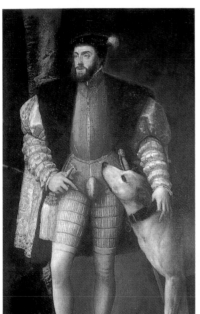

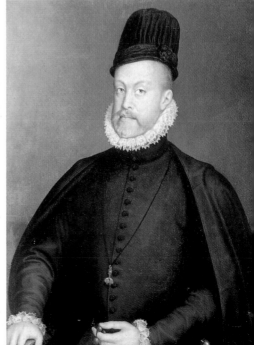

■ Titian, *Portrait of the Emperor Charles V*, Museo del Prado, Madrid. This portrayal of the king suggests majesty and power.

■ Right: Sofonisba Anguissola (attributed), *Portrait of Philip II*, c.1575, Museo del Prado, Madrid.

More than a "painter of heads": fresh challenges

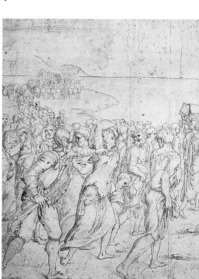

■ Frontispiece to the *Art of Painting,* by Francisco Pacheco, 1649. The treatise on painting by Velázquez' master concentrated mainly on traditional and religious subjects.

Diego Velázquez was summoned to the court in Madrid shortly after the death of Rodrigo de Villandrando in 1622, and was soon appointed his successor as court painter. The presence of an official painter in the royal palace proved the importance of art – it illustrated the power of the throne. The political activities of the royal family were displayed alongside celebratory pictures on themes associated with great, heroic enterprises, and it was possible to read hidden political statements even into the views of Spanish and foreign cities. The ruler was reminded of his power and the wealth of his own domains, and visitors would be impressed by the extent of the territories of the nation in which they were guests. Velázquez handled this delicate subject-matter with his customary assurance, attracting the envy of contemporary painters who had earlier alleged that "all his mastery is confined to knowing how to paint a head".

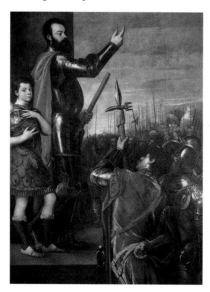

■ Titian, *Speech of Alfonso of Avalos,* 1540–41, Museo del Prado, Madrid. Titian was another great artist who worked for the court of Madrid and devoted himself to the celebration of historical events. This scene of the general addressing his troops is solemn and formal, narrated with gestures of almost theatrical emphasis.

■ Even though never conceived as the principal element, Velázquez' landscapes occasionally reveal considerable expressive ability, as in the case of the *Portrait of Prince Baltasar Carlos on Horseback*, c.1635, Museo del Prado, Madrid (left, detail).

■ Below: Taddeo Zuccari, *Charles V and Francis I*, 1559–66, Farnese Palace, Caprarola. Like the Spanish royal family, Italian royalty also wished to demonstrate its greatness by recording the important events affecting the family.

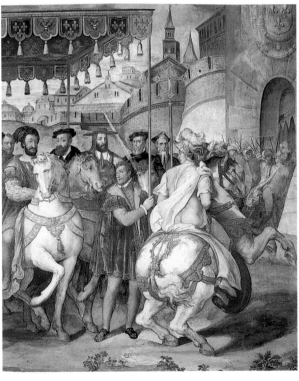

■ Above: Vicente Carducho, *The Expulsion of the Moors*, 1627, Museo del Prado, Madrid. This was one of the few battle scenes that Carducho depicted.

The Feast of Bacchus

Velázquez finished this work (Museo del Prado),
in 1629. It is a humorous parody of the world of
myth and of human weaknesses, as the drunken
revellers and the gods celebrate together. An
alternative title is *Los Borrachos* (*The Topers*).

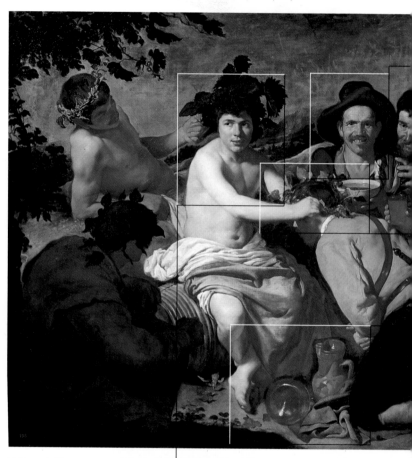

■ The central figure
is a plump, naked boy
in the role of the god
Bacchus; he is crowning
his devotee while
looking away from
the ceremony, and
the vine leaves sit
awkwardly on his head.

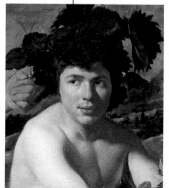

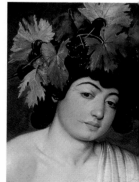

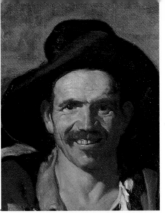

■ The laughing, drunken man who looks straight out of the canvas holds a bowl of wine, echoing symbolically the shadowy figure of the beggar who holds out his hand in the background. The beggar represents the Christian virtue of Charity, and is ignored by the group.

■ The hands of Bacchus place the crown on the head of a kneeling man, whose awkward position accentuates his humble status. The gesture appears as a profane mimicry of religious ritual.

■ There is an exceptional example of still life at the feet of Bacchus. It is as if these objects – a pitcher and a glass bottle, of which only the base is visible, are offerings to the god. The reflections that accentuate the shapes are finely executed.

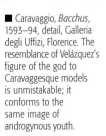

■ Caravaggio, *Bacchus*, 1593–94, detail, Galleria degli Uffizi, Florence. The resemblance of Velázquez's figure of the god to Caravaggesque models is unmistakable; it conforms to the same image of androgynous youth.

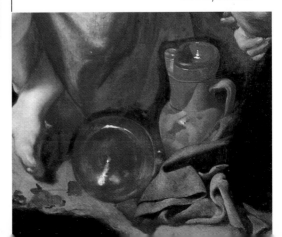

41

Rubens in Madrid

■ Right: Fernando Gallego, *Christ Blessing*, 1467–70, Museo del Prado, Madrid. Gallego was one of the last Castilian artists to be influenced by the Flemish style.

■ Peter Paul Rubens, *Adam and Eve*, 1628, Museo del Prado, Madrid. A copy of Titian, painted during Rubens' second journey to Madrid. In the opinion of contemporaries, the work of the Flemish artist surpassed that of the Venetian master.

The first contact that Peter Paul Rubens made with Spain was in 1603 when he went to Valladolid as a diplomat. On that occasion he impressed the prime minister, the Duke of Lerma, who he painted on horseback with insight and expressive flair. He had come from Italy with paintings and diplomatic messages, and in the works of that period it is possible to discern the influence of El Greco combined with Italian elements. In 1628, still on a diplomatic mission for the regent of Flanders, with a view to negotiating the ending of the Thirty Years' War, Rubens made a second and longer visit, staying in Madrid for almost a year. It was a prolific period for the painter, who was made welcome by Philip IV. Lodged at the royal palace, he familiarized himself with the king's art collection, in particular studying and copying the late works of Titian. Probably he worked in the studio of Velázquez, with whom he shared an admiration for the Italian master, and who had impressed them both with his creative strength and also with the popularity and status he had gained, both with the public and with other artists.

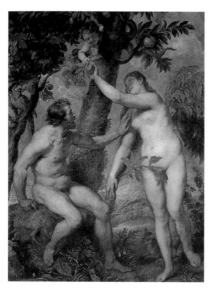

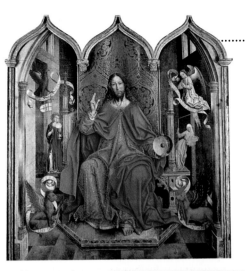

Flemish influence upon Spanish art

Since the 15th century, there had been many exchanges between Spain and the Low Countries. Spain imported from Flanders a considerable number of art works, and the influence of Flemish work could be detected in much of Spain's artistic output. Spanish art built on Flemish achievements in the naturalistic observation of reality, and in doing so partly rejected the stylistic conventions and tradition of the Italian Renaissance.

■ Right: Peter Paul Rubens, *Adoration of the Magi*, 1609, Museo del Prado, Madrid. At the start of the 17th century, Rubens' work was extremely popular in Antwerp.

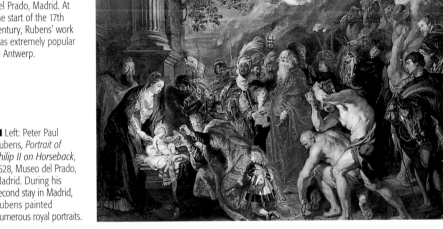

■ Left: Peter Paul Rubens, *Portrait of Philip II on Horseback*, 1628, Museo del Prado, Madrid. During his second stay in Madrid, Rubens painted numerous royal portraits.

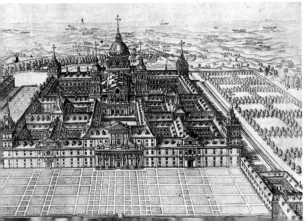

■ In Madrid Rubens visited the Monastery of San Lorenzo at the Escorial, very probably accompanied by Velázquez, the only painter with whom he had contact in the course of his diplomatic and artistic mission. He may already have known him through a previous exchange of letters.

43

The Count-Duke de Olivares

This was the first standing portrait of Don Gaspar de Guzmán de Olivares, painted in 1624 (Museu de Arte, São Paolo, Brazil). Later artists were expressly instructed to represent him in heroic, exalted poses.

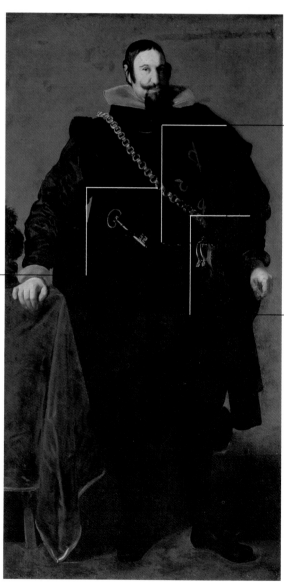

■ The key of the major domo is very prominent in this frontal portrait: it is the most important symbol of the social status of the count-duke, and stands out resplendent against his dark clothing, attached at the same angle as the imposing gold chain over the shoulder.

■ The embroidered red cross on the chest indicates that the bearer belongs to the order of Calatrava. In the portrait in the Verez-Fisa Collection, however, the count-duke displays the insignia of the order of Alcántara.

■ The same pose is adopted for another portrait (below: José Luis Verez-Fisa Collection, Madrid), completed between 1622 and 1627. The subject's expression appears more decisive, and the splendor of the materials and the delicacy of the hands are accentuated.

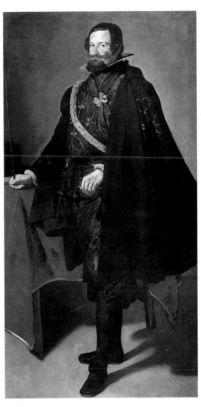

■ The spurs which are portrayed hanging from a gold chain are omitted in the later portraits. Here, they relate to the count-duke's post at the time of "Master of the Horse".

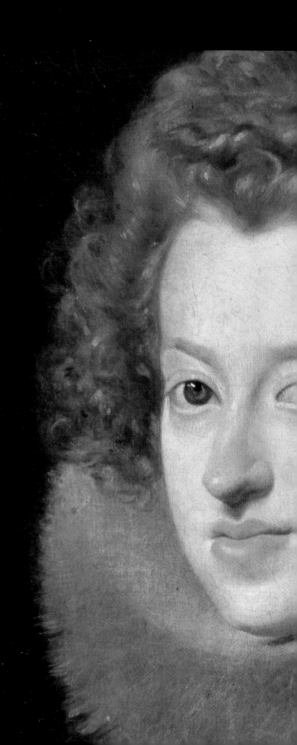

Velázquez, *Doña María, Queen of Hungary (detail)*, 1630, Museo del Prado, Madrid.

The artist's life in the Golden Age

During Spain's Golden Age, the tremendous surge in artistic activity throughout Andalusia led both academics and artists to argue for the elevation of painting to the same status that other arts – such as literature, theatre, and poetry – had attained. An artist, bound as a craftsman who payed taxes, could not be permitted to attain to the rank of titled nobility. However, from a purely financial point of view, a recognized artist in Spain found himself in a reasonably well-off position: often he owned a house and employed a number of servants. Furthermore, he was privileged in that he was able to come and go freely wherever he pleased, and could choose to work more or less anywhere. The court architects, obliged by royal bidding to involve themselves in important projects, were particularly well travelled. Wealthy patrons, who were also connoisseurs of the arts, encouraged painters to broaden their cultural background and gave them access to their collections and libraries. This new rapport between clients and practitioners was invaluable in helping painters to enrich the scope of their knowledge, learning, and experience.

■ Right: Juan Bautista Martínez del Mazo, *The Painter's Family*, detail, c.1659, Kunsthistorisches Museum, Vienna. The painter shown at work here could be Velázquez himself.

■ Below: artists such as Velázquez were privileged in that, like the nobility, they were permitted to travel by coach.

■ Left: *Philip II* (late 16th-century engraving, Bertarelli Collection, Milan). Philip forbade Spanish students to attend foreign universities.

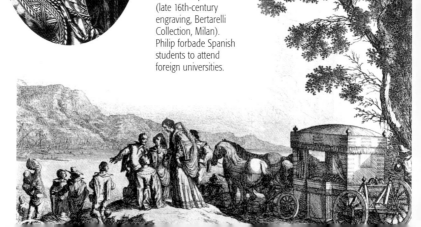

■ College of Santa Cruz, Valladolid. The Emperor Charles V had frequently stayed in this important Castilian cultural centre, where he was surrounded by writers and artists.

■ Below: Velázquez, Portrait of *Juan Martínez Montañes*, c.1636, Museo del Prado, Madrid. The works of this sculptor from Seville, who for the most part remained in his own region, found their way to Madrid and even as far as South America.

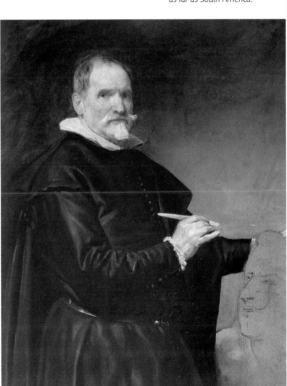

■ Below: Juan Rizi, *Fra Alonso da San Vittore*, c.1659, Museo di Burgos, Burgos. A Benectine monk, Rizi was known for his fine portraits as well as his austere tenebrist work.

Cultural exchange between Spain and Italy

In comparison with the previous century, fewer Spanish painters visited Italy during this period. However, Velázquez went there twice and Martínez del Mazo, Jusepe Martínez, and Francisco Jimenéz each made one trip – an opportunity to learn the latest Italian art theories. Occasionally, Italians also placed themselves in the service of the Spanish court. In the late 16th and 17th centuries, various Italians artists travelled to Spain: some remained long-term, while others completed important works before returning home. All of these elements helped keep alive the tradition of cultural exchange between the two countries.

1629-1630

The journey to Italy

O n August 10, 1629, Velázquez left Barcelona for Italy. He went with the permission of His Majesty, who gave him 400 silver ducats, while the count-duke provided him with another 200 gold ducats, a medal with the king's portrait, and various letters of introduction. He travelled with the intention of broadening his knowledge of Italian art, and his principal destinations were the cities of Venice and Rome. His close rapport with the king led to his appointment to the position of "Usher of the Chamber", and he was charged with important duties outside his role as court painter. Departing with the marquis Ambrogio Spinola, he landed in Genoa, and then went on to Milan and Venice as guest of the Spanish ambassador. Here he was able to study the works of Tintoretto and Veronese, who he already admired, in the Basilica and Scuola di San Marco. He visited the Council Chamber at the Scuola di San Luca, where he had to be accompanied by servants of the ambassador because of the delicate political situation arising from the war of succession in Mantua, which was creating hostility between Venetians and Spaniards. After studying at length the great works of Venetian masters (Titian, Veronese, Licino, Bassano, Bellini, Palma, Giorgione, and Sansovino), Velázquez left Venice, making further fruitful stops at Ferrara, Cento, Bologna and, finally, Rome.

■ View of the Piazza of the Madonna at Loreto, from the *Present State of All the Countries and Peoples of the World*, Venice, 1757. Loreto, the Marian city, was a popular destination for pilgrims.

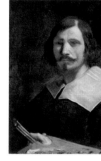

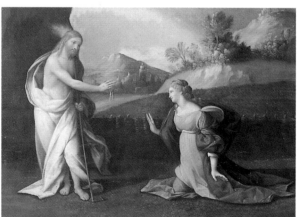

■ Above: Guercino, *Self-Portrait*, c.1624–26, Richard L. Feigen & Co., New York.

■ Left: Garofalo, *Noli Me Tangere*, c.1515, Pinacoteca Nazionale, Ferrara.

■ Below: Tintoretto, *Translation of the Body of St Mark*, 1568, Accademia, Venice.

■ Below: Velázquez, *Head of a Stag*, c.1626–30, Museo del Prado, Madrid. This work was probably begun before Velázquez' departure from Madrid, and finished on his return from Italy.

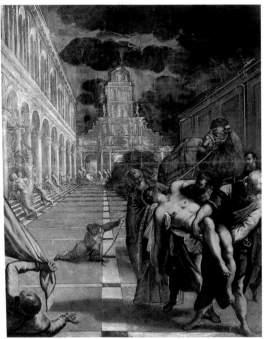

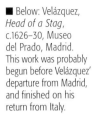

■ Below: Francesco Valegio, *The Crucifixion of St Roch*. This print was completed in the first half of the 17th century to satisfy a growing demand for reproductions of Tintoretto's *Crucifixion of St Roch*, a popular work of the time.

The Italian influence

Comparisons between the works completed before his journey to Italy and those after suggest that certain techniques, with which Velázquez had experimented for some time, became intrinsic to his style after this first visit. One change was that his palette became more luminous and wide-ranging, notable in portraits such as *Queen Isabel* (1631-32, New York, private collection). The later equestrian royal portraits may well have been influenced by Italian equestrian compositions, such as Verrochio's gigantic *Bartolommeo Colleoni* in Venice, and the *Cavallo* of Marcus Aurelius in Rome. It has been suggested that the *Head of a Stag* in the Prado (above) was completed after the painter's return, and has an Italian influence.

Venice in the early 17th century

For Venice, the 17th century was a difficult time. No longer the main port for receiving products from Asia, it lost its share of the Mediterranean trade and had problems with its commercial fleet, which had to compete with the English, the French, and the Dutch, who were all laying the foundations of their vast colonial empires. The government rocked under the struggles between the "youngsters", who aimed to redress the balance between the Council of the Ten and the Senate and to reaffirm the position of Venice in Europe, and the "elders", who tended towards the primacy of the Council of the Ten and followed a prudent line in foreign affairs. Challenging the Spanish presence in Lombardy, Venice became involved in the conflict that broke out between the governor of Milan and the Valtellina, and also in the war of succession in the duchy of Mantua. In the cultural sphere, the intellectuals formed clubs that met and discussed artistic matters; yet no great creative personalities emerged, and the city experienced a sharp decline, remaining within its 16th-century tradition.

■ Below: This 17th-century map shows the city of Venice (Bertarelli Collection, Milan). Having lost its prestigious role as the principal port for trade with the Orient, Venice became isolated. It still welcomed artists from abroad, but its native painters continued in the tradition of Titian, Tintoretto, and Veronese.

■ Antonio Bellucci, *The Vow of the Doge to St Lawrence Justinian to Intercede for the Cessation of the Plague of 1447*, Castle of Santo Spirito, Venice.

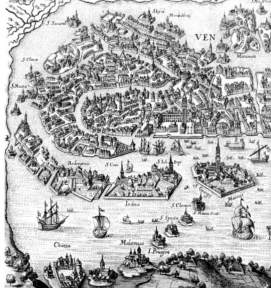

■ Joseph Heintz the Younger, *Popular Festival in St Mark's Square*, 1648–49, Galleria Doria Pamphili, Rome. The landscape of St Mark's Square would be explored memorably in the next century by Canaletto. Here, Heintz chronicles a public celebration.

■ Below: Bernardo Strozzi, *The Rape of Europa*, before 1644, National Museum, Poznan. This Genoese artist moved to Venice in 1630. The exquisite variation and density in his application of color made him one of the greatest exponents of Venetian painting.

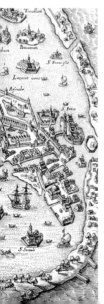

■ Right: Giovanni Coli and Filippo Gherardi, *Triumph of Wisdom*, 1664, Library of San Giorgio Maggiore, Venice. In the second half of the century, several artists became involved in a Veronese revival.

Rome: classicists, *Caravaggisti*, and *bamboccianti*

■ Right: Michelangelo Cerquozzi, *The Watering Hole*, c.1640, Galleria Nazionale d'Arte Antica, Rome. This is a modest and sincere depiction of the everyday life of ordinary people.

At the start of the 17th century, Rome was the cultural centre of Italy, with many different artistic trends. The revival of 16th-century painting was based on the classical tenets of the Academy of the Incamminati. This was also the time of the Caracci brothers, who met with great success in Rome, while also finding similarities with the Neo-Venetian movement. This began to emerge after 1630, based explicitly on the application of the colorist principles of the 16th-century Venetian masters. In choice of subject, it ranged from grand statements in the Baroque style, associated with the events of the Counter-Reformation (episodes with heroic figures, rich in color and ambitious in composition) to more restrained and cultivated historical and mythological scenes. From that time the "Caravaggio phenomenon" gradually lost ground; this had influenced many artists – including the classicist Guido Reni – who were known as the *Caravaggisti*. Typically Roman and resolutely opposed to the classical revival was the *bamboccianti* movement. Condemned in official art circles, with its interest in domestic genre scenes, it concentrated on the minor aspects of everyday peasant life.

■ Gian Lorenzo Bernini, *Apollo and Daphne*, 1622–25, Galleria Borghese, Rome. This is an exquisite depiction of the metamorphosis of Daphne.

■ Pietro da Cortona, *The Triumph of Divine Providence*, c.1630, Palazzo Barberini, Rome. Pietro da Cortona specialized in splendid stage settings, with figures in spectacular poses.

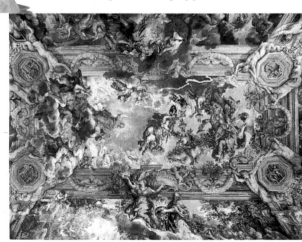

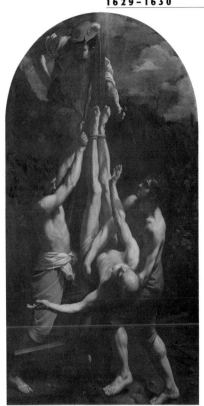

■ Below: Domenichino, *Diana at the Chase*, 1616–17, Galleria Borghese, Rome. Domenichino revived the antique style in this depiction of an archery contest, based on an episode from the *Aenied*. It was suggested to him by the art theorist Monsignor Giovanni Batista.

■ Guido Reni, *Crucifixion of St Peter*, 1604, Vatican Library, Rome. Reni was among the first generation of artists to revive the classical genre. The works of his Roman period, however, show the definite influence in their lighting and naturalism of Caravaggio.

LIFE AND WORKS

The arrival in Rome

Diego Velázquez arrived in Rome in 1630 and stayed there for a year, assisted by Cardinal Barberini, the nephew of Pope Urban VIII. His first home was in the Vatican Palace itself, where, according to Pacheco, he was given possession of the keys to certain rooms, one of which contained frescos by Zuccari. Despite such luxurious accommodation, the painter decided to leave the palace, a move that gave him the opportunity to study classical sculpture in greater detail. Thanks to the interest of the ambassador, the Count of Monte Rey, Velázquez managed to move to the Villa Medici, at Trinità dei Monti. Here, he spent two months studying and carefully copying various Roman works of antiquity, which later became models for his own work. Velázquez felt relaxed in the Roman atmosphere; in his principal paintings of this period – *The Forge of Vulcan* and *Joseph's Cloak* – he blended the rigor and balance of Emilian tradition with Venetian coloration. Before returning to Spain he visited Naples, where he painted the king and queen of Hungary.

■ Velázquez' first influential contact in Rome was with Cardinal Barberini (above), nephew of the Pope, who obtained for him comfortable lodgings in the Vatican Palace.

■ Velázquez passed the summer in this villa belonging to the Medici family.

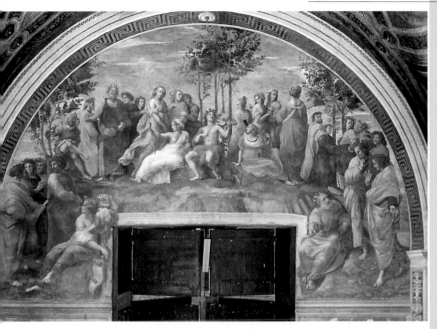

■ Velázquez, *Woman as a Sibyl*, c.1630, Museo del Prado, Madrid. Probably painted in Rome or soon after the artist's return to Madrid, this is thought to be the portrait of his wife Juana. The composition is classical, the features naturalistic, and it is very similar in style to traditional Italian painting exercises.

The Forge of Vulcan

This work was painted during Velázquez' stay in Rome in 1630 (Museo del Prado, Madrid). It was probably influenced by the work of Guido Reni and by classical statuary.

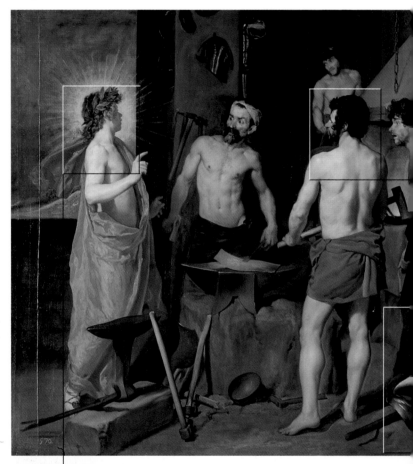

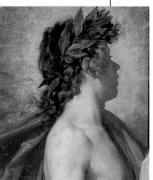

■ Particularly delicate is the head of the young god, framed by a halo of rays that seem to illuminate the otherwise dull light surrounding the forge.

■ Preparatory sketch, *Head of Apollo* (Private Collection, New York). Here, the profile appears more effeminate than that of the finished, more heroic-looking Apollo.

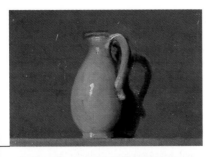

■ Another crisp and exquisite still life is the jug on the mantelpiece. The hint of color in this, along with the blue of Apollo's sandals and the patch of sky, enliven the predominantly black and brown painting.

■ Seen from behind with bare shoulders, the blacksmith, representing the god of fire at his forge, is perhaps the most academically accomplished element of the whole scene. He is reminiscent of many models of heroic statuary, but his forelock and sideburns suggest a more contemporary working man.

■ The armor that Vulcan is forging for Mars is contemporary in design. It is a splendid example of still life and the third point of light in the composition, along with Apollo's halo and the glare of the flames that blaze in the mouth of the furnace. Velázquez has not forgotten the genres studied during his period in Seville, here enriched with a more stylistic meticulousness.

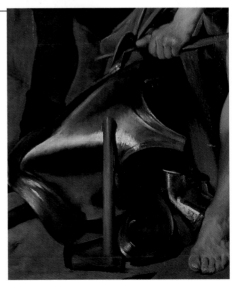

Joseph's Cloak

Another work of 1630 (now in the Monasterio De San Lorenzo de la Escorial), this was completed in Rome, perhaps as a companion to *The Forge of Vulcan*. It is probably an allegory on the subject of betrayal and deceit.

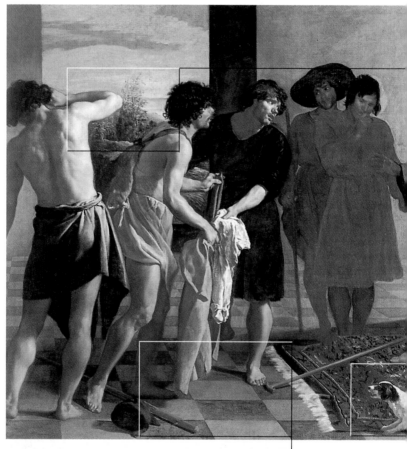

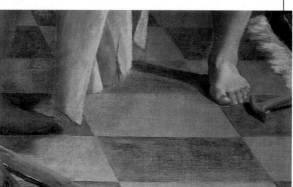

■ The chequered floor is an exceptional detail, displaying a meticulous study of the rules of perspective in the Italian manner. The floor becomes lighter and loses detail as it

■ The youth turns away and brings his right hand to his face with a theatrical gesture worthy of Bolognese and Roman academism. Behind him appears an elegant landscape of bluish tones, further evidence of the artist's mastery of detail.

■ The puppy barks at the deceitful brothers of Joseph, as if sensing their treachery. It is a lively detail that indicates once again the painter's observational skill. In later works, dogs appear in their traditional role as symbols of loyalty.

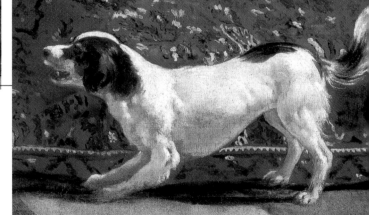

recedes. The effect of spatial depth in the painting is also obtained in part by the stick left lying on the ground, which follows the diagonal direction of the young men's shadows.

LIFE AND WORKS

An industrious draughtsman

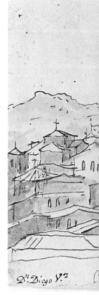

Biographers of Velázquez agree that he was extremely active as a draughtsman, beginning with his early work in Seville, when he drew with charcoal and chalk on blue paper. He continued drawing during his trip to Italy, and probably sketched many works, including Titian's *Rape of Europa*, which featured in his *Fable of Arachne*. His sketches and drawings were essential source material for future works, especially useful in the accurate reproduction of facial expressions. However, only a dozen or so sketches that can definitely be attributed to Velázquez survive. His early drawings are obviously influenced by his teacher Francisco Pacheco, but also reveal his own characteristic confidence. Velázquez' translation of his preparatory sketches into finished versions demonstrates his skill in conveying the essence of earlier observation, then building on it with his masterly handling of color and texture.

■ Above: Velázquez, *Portrait of Cardinal Borgia*, 1643–45, Real Academia de Bellas Artes de San Fernando, Madrid. This is an impeccably natural portrait of the archbishop of Toledo. Velázquez employs only a few strokes to capture successfully the essence of his subject.

■ Below: Velázquez, *The Fable of Arachne* (*The Spinners*), c.1657, Museo del Prado, Madrid. In the alcove at the rear of the painting hangs a tapestry: it is Titian's *Rape of Europa*. Velázquez regarded Titian as one of the greatest Italian painters.

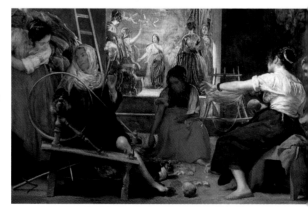

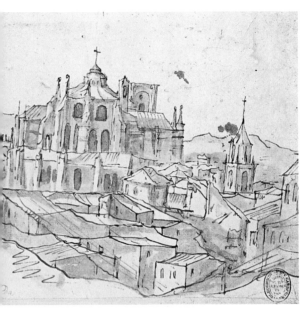

■ Velázquez, *The Cathedral of Granada*, Biblioteca Nacional, Madrid. During a visit to Granada in 1629, Velázquez used the occasion to draw the image of the cathedral on paper, capturing the light and atmosphere of the scene.

■ Below: Velázquez, *Head of a Girl*, Biblioteca Nacional, Madrid. From the body of drawings that are said to be by Velázquez, this is one that can be attributed with certainty. It is thought to be the likeness of his wife.

■ Above: Velázquez, *Head of a Girl*, Biblioteca Nacional, Madrid. This drawing probably depicts the younger of the Pacheco sisters. The technique clearly owes something to the subject's father, Francisco Pacheco. The same suggestion of innocence and charm was captured later in Velázquez' portraits of children.

1629–1630

Prince Baltazar Carlos and a Dwarf

Probably the first work completed on his return from Italy, at the beginning of 1631, this portrait (Museum of Fine Arts, Boston) is the earliest likeness of Baltasar Carlos, hereditary prince and son of Philip IV and Isabella of Bourbon.

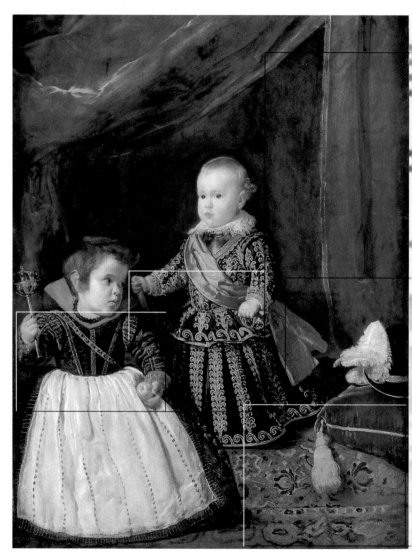

■ The hands of the prince are busy with symbols of his status: in his right is the baton of command, while the left rests on the hilt of his sword, the blade of which is concealed behind the red sash of the gold-embroidered costume.

■ The representation of the dwarf is freer in style and posture than that of the prince, who is stiffly official in his robes. The prince's face is smooth and glowing, while the dwarf's is more shadowy and uneven. Instead of a sash, she sports a belt of imitation jewels. The dwarf appears as a foil to the majestic Prince.

■ The floor of the painting is divided into two horizontal planes, which may have been completed at different times, and which signify a clear separation between the prince – who stands higher up – and the dwarf. There is the implication of a picture within a picture, as if the dwarf were in front of a painting and not in the actual presence of the prince.

The Council of Trent and religious art

Six of the fifteen members of the commission for sacred imagery at the Council of Trent were Spaniards, and one of them was father superior of the Jesuits. His presence influenced the development of religious art of the so-called post-Tridentine period in Spain, whereby the council sanctioned forms and styles that exemplified the new official attitudes. Yet the symbolic prescriptions of the council were not sufficient in themselves to create a new style, and recommendations for a plain, spare, unadorned form of art founded on moderation were not heeded by the artists of the Baroque. The Jesuits, however, came to influence art, both by extolling the role of non-figurative elements such as light, and by pursuing the trend of illustrating abstract ideas. This produced the most frequently repeated and venerated images of the Golden Age, such as that of the Immaculate Conception. Lay brotherhoods and societies throughout Spain propagated the most cherished themes of the religious orders in an iconography that revived devotion to Jesus and Mary, the Eucharist, and the patron saints of the individual cities.

■ Above: Alonso Cano, *The Immaculate Conception*, c.1647, Museo Provincial di Alva, Vitoria. This work was probably painted for Don Pedro de Urbina de Montoya, future archbishop of Seville.

■ Left: Bartolomé Peréz, *Garland of Flowers with St Anthony and the Baby Jesus*, after 1689, Museo del Prado, Madrid. Towards the end of the century, the *bodegón* and floral motifs came to be combined with images of piety.

■ Left: Andrea del Pozzo, *Glory of St Ignatius*, 1691–94, Sant'Ignazio, Rome. This grandiose fresco, celebrating St Ignatius of Loyola, founder of the Jesuit order, embodied the artistic ideal of the Church, yet was far removed from the restraint urged by the Council of Trent.

■ Below: Daniele Crespi, *Mass of St Gregory the Great*, 1615–17, San Vittore, Varese. This painting was an attempt at an all-encompassing, emotional representation of a mass, while also making reference to the council's reforms under St Charles Borromeo.

The weight of popular devotion

The Spanish reaction to the personal, internal faith of Protestantism was to encourage a form of community religion that went beyond the traditional places of worship. Representations of the saints became popular icons, often depicted at the most painful moment of their martyrdom or earthly life, or other mystical events. One of the most popular themes was the Immaculate Conception, already taken in Spain to be dogma even before it was so declared by the Church in 1854. It became an almost obligatory subject for most artists after virtually the whole of Spain took on the doctrine.

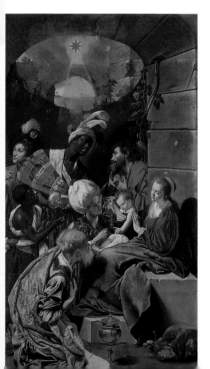

■ Left: Juan Bautista Maino, *Adoration of the Magi*, 1611–13, Museo del Prado, Madrid. This is an unconventional, idealized, and colorful Jesuitical interpretation of the scene.

■ Right: El Greco, *Dream of Philip II*, 1577–79, Monastery of San Lorenzo, Escorial. The religious spirit of Spain in the Golden Age is encapsulated in this allegory of victory in the battle of Lepanto, interpreted as the adoration of Christ.

The second phase of religious painting

Velázquez' training was now complete. When he resumed his life and artistic duties at the palace, he went back to the religious subjects that had originally occupied him in Seville, while also working on court portraits. A classical style derived from Italian painting may be detected in the composition of *Christ on the Cross* and *Christ at the Column*, and in the use of extraordinary *alla prima* color effects in *St Anthony Abbot* and *St Paul the Hermit*. Velázquez continued to work for the king, painting religious works without becoming fanatical or ostentatious. He built on his previous style, but also included symbolic and allusive elements, seen in the accomplished and naturalistic representations of the *Temptation of St Thomas Aquinas* and, even more so, in *Christ at the Column*. Here, he exhibited his familiarity with mystical literature in rendering visible the spiritual communication between Christ and the child, symbol of the Christian soul. Under the watchful eye and protective gesture of the angel, Christ is bound to the column by means of a thin ray of light that extends from His head to the heart of the boy.

■ Velázquez, *Christ at the Column*, 1632, National Gallery, London. The traditional symbols of the Passion are placed in the foreground like a study in still life.

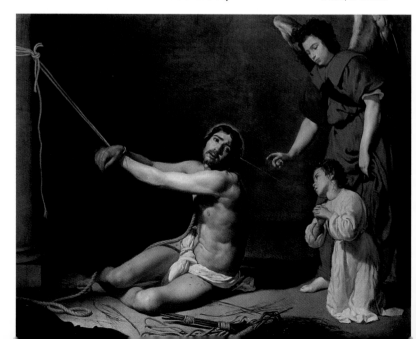

■ Velázquez, *The Coronation of the Virgin*, detail, c.1643, Museo del Prado, Madrid. This was painted for the oratory of the queen, using a range of blues and violets. The worship of Mary was particularly widespread: Protestant doctrine denied the cult of the Virgin, but the Council of Trent was resolute in its attempt to revive the role of the mother of God.

■ Above: Velázquez, *Temptation of St Thomas Aquinas*, 1632, Museo Diocesano, Orihuela. The saint, exhausted after his temptation, is comforted by the angels.

■ Velázquez, *St Anthony Abbot and St Paul the Hermit*, c.1635, Museo del Prado, Madrid. Probably painted for a small shrine in the gardens of the Buen Retiro, this lively work shows the episode from the Golden Legend of the visit of Saints Anthony and Paul the Hermit, set against a landscape in the Italian style.

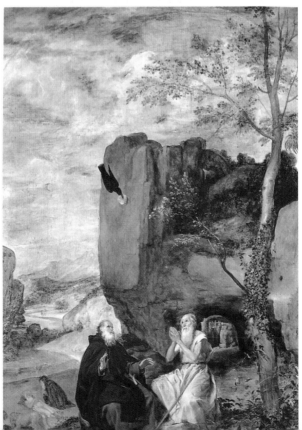

The Buen Retiro palace

■ Velázquez, *Philip IV on Horseback*, 1628–34, Museo del Prado, Madrid. This was one of the first works commissioned for the new palaces.

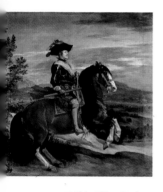

Buen Retiro was a palace surrounded by gardens, built on a site previously occupied by an aviary owned by the count-duke. It had been flanked by a group of buildings erected in the reign of Philip IV by Juan Bautista de Toledo, and was known as "the retreat" because the king was in the habit of retiring there at times of mourning and penitence. The count-duke had offered to build Philip IV an enormous palace, which was to become a symbol of the exalted Spanish monarchy. It contained everything the other ancient palace in Madrid lacked: open spaces, gardens, pavilions, fountains, residences decorated with the works of the great artists, and a theatre to stage the works of the finest contemporary playwrights. For the king, it also meant the opportunity to escape the formal, ceremonial court and devote his time to the hunt. The popularity of hunting led to the construction of suitable residences outside Madrid, buildings that were less sumptuous than the palace, but comfortable, situated at Aranjuez, the Zarzuela, El Pardo, and Valsaín, where the members of the court alternated their visits when they left the capital.

■ Right: Titian, *Charles V*, 1584, Museo del Prado, Madrid. Charles V had imposed a rigid code of etiquette on palace life, which he also imposed on the Burgundian court.

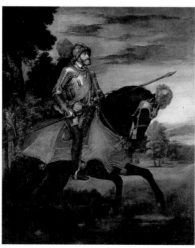

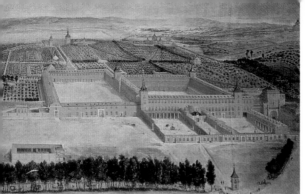

■ Jusepe Leonardo, *Buen Retiro Palace*, Museo Municipal, Madrid. The grandiose complex of Buen Retiro was inhabited by the royal family and a court consisting of the high nobility and all their servants. Thousands of people lived there as a self-sufficient community.

■ Right: Velázquez, *Prince Baltasar Carlos in the Riding School*, c.1636, Wallace Collection, London. This scene depicts court life at the Buen Retiro: the young prince is having a riding lesson attended by the preceptor, the count-duke, and the nobles of the court.

■ Below: Juan Bautista Martínez del Mazo, *The Gardens of the Palace of Aranjuez*. Situated not far from Madrid, Aranjuez was furnished with a fine palace and elegant gardens.

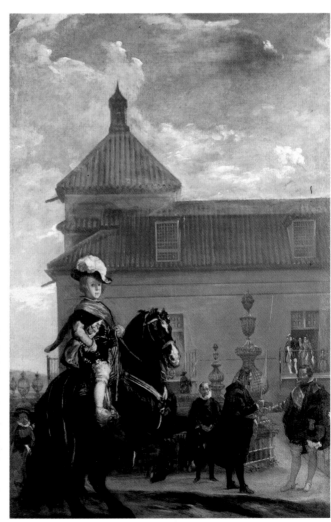

Velázquez
at the Buen Retiro

V elázquez returned to Madrid in time to be included among the artists assigned to decorate the Buen Retiro. He himself had chosen many of the works and arranged for them to be brought from Italy, but now he could participate directly in the project, alongside many Madrid painters. Some, like Carducho and Cajés, were already court artists, and others, like Zurbarán, were summoned expressly for the occasion. The palace was to be a place to celebrate the monarchy and the king, and Velázquez was entrusted with the decoration of the Salón de Reinos (Hall of the Realms), so-called after the 24 Spanish monarchs painted in the lunettes. For this room, with its awkward architecture of open interior windows and balconies in the walls, he produced a series of equestrian portraits of Kings Philip III and Philip IV, their wives, and the heir to the throne. In addition, there were to be large paintings devoted to the theme of Spanish victories all over the world, of which Velázquez would personally contribute *The Surrender of Breda*. The other pictures were assigned to the collaborators he selected, all free to express themselves stylistically. The famous hall was used for court spectacles, but also served as a reception area and throne room.

■ Above: Antonio Tempesta, *Nero*, engraving in the series *The Caesars*. For 17th-century painters, prints were important source material.

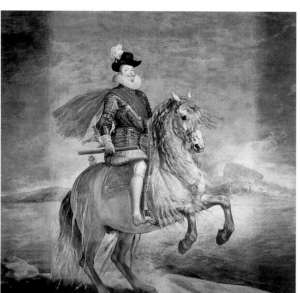

■ Velázquez, *Philip III on Horseback*, c.1630, Museo del Prado, Madrid. This portrait was probably commissioned in 1628 and finished much later; visible retouchings are evident.

The equestrian portrait

The Renaissance re-established the grandeur of the equestrian portrait, with its image of the mounted military commander created according to the aesthetic precepts of antiquity. In the 17th century, the equation of such a portrait with an implicit celebration of authority led to the horse being seen as a kind of movable throne. The image symbolized power, heroism, and majesty, and it was adopted by many artists in order to emphasize the exalted social position of the subject. In Spain, the equestrian portrait was confined to celebrate the grandeur of the royal family and upper nobility.

■ Velázquez, *Portrait of Isabella of France on Horseback*, 1636, Museo del Prado, Madrid. Isabella's pose is a mirror image of that of her husband Philip IV; the portrait was begun in 1629 and took seven years to complete.

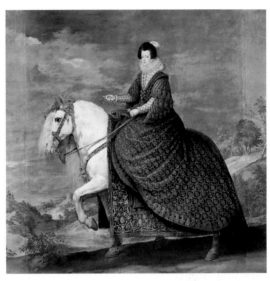

■ Below: A reconstruction of the wall of the Hall of the Realms, based on a study by Jonathan Brown (1980).

■ Velázquez, *Portrait of Prince Baltasar Carlos on Horseback*, 1635. Museo del Prado, Madrid. The most attractive of the portraits in the throne room is that of the prince and heir. The perspective from below takes into account the painting's position, hanging above the entrance door.

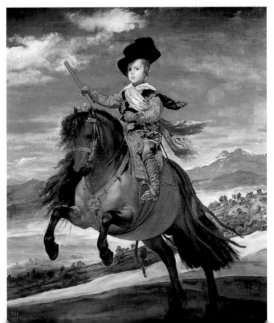

Philip IV on Horseback

Arguably the finest of those included in the Hall of the
Realms of the Buen Retiro (now in the Museo del
Prado, Madrid), this portrait of the king was
undoubtedly painted in its entirety by Velázquez. The
date, still debated, was between 1628 and 1635.

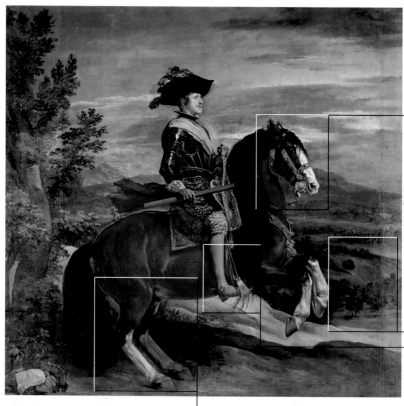

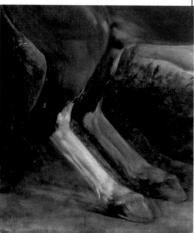

■ The elegant posture
of horse and rider,
wholly befitting an
experienced horseman
such as Philip IV (who
was taught at the
famous riding school
of Vienna), is based
on the solid strength
of the animal's hind
legs. The passage
of time has increased
the transparency of the
layers of color, clearly
revealing some re-
thinking by Velázquez,
who slightly altered the
position of the horse,
moving back the hind
legs a few centimetres.

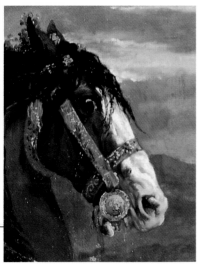

■ A contemporary work remarkably similar to Velázquez' painting is the statue of Philip IV on horseback, in the Plaza de Oriente, Madrid, completed by Pietro Tacca in about 1640. It introduced to monumental sculpture the motif of the prancing horse.

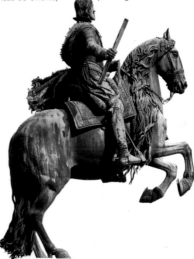

■ The painting is stately and monumental, and the bay horse, with its white muzzle and feet, is seen wholly in profile; the effort of the horse, underlined by the dilated nostrils and drops of sweat, contrasts with the effortless pose of the king.

■ The panoramic landscape of the kingdom unfolds below the ruler's elevated position. The vista of hills and trees is reminiscent of the Pardo area; the muted, slightly blurred bluish tones convey the sense of distance.

■ The king is firmly seated in the stirrups, his movement almost imperceptible as he touches the spur to the flanks of the horse in order to stimulate the prancing attitude.

The realistic rendering of a position that can only be held for a few seconds is proof of the artist's long and attentive observation of the finer points of horsemanship.

Historical and celebratory painting

■ Below: Paolo Veronese, *The Family of Darius Before Alexandria*, 1565–67, National Gallery, London. Here, the family of the defeated Darius III yields the crown to Alexander the Great. Plutarch praised the noble spirit of Alexander in his behavior towards the family of his vanquished enemy.

Among the various genres of figure painting, the representation of historical events – so-called history painting – is particularly interesting. Artists did not perform just the straightforward documenting of an ancient or contemporary historical event, but transformed the narrative into a celebration of victory. This subjective version of history usually tells the stories of heroic men who are the protagonists of great exploits, or of noblemen who wish to see themselves immortalized in particularly grand situations. The genre was particularly popular in the late 16th century and throughout the 17th century, and usually focused on the representation of ancient heroes. The academic theorists of the time viewed history painting as second only in importance to religious works. Many royal and noble men commissioned works portraying themselves as historic heroes. The early 17th century saw the beginning of the Thirty Years' War, involving all the great powers of Europe, and resulting in widespread destruction, mass slaughter, and famine. In this war, artists were propagandists, justifying and exalting their ruler and country.

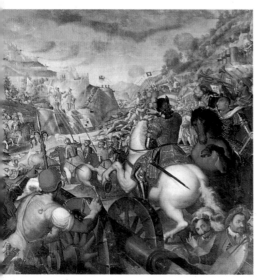

■ Grazio Cossali, *The Appearance of Saints Faustino and Giovita at the Siege of Brescia*, 1603, Santi Faustino e Giovita, Brescia. Often a historical episode was embroidered with the extraordinary appearance of saints, who interceded in order to influence events favorably.

■ Above: Jacques Courtois (1621–76), *Battle Between the Moors and Christians*, Museo del Prado, Madrid. A prolific painter of lively battle scenes, Courtois' style is reminiscent of Salvator Rosa.

■ Right: El Greco, *The Martyrdom of St Maurice and the Ten Thousand Thebans*, 1582, Monastery of San Lorenzo, Escorial. This historical episode assumes a political significance.

■ Right: Antonio Calza, *Battle*, second half of 17th century, Museo di Castelvecchio, Verona.

79

The Surrender of Breda

The keys of the city of Breda were handed over in 1625 and Velázquez painted this (Museo del Prado, Madrid) for the Buen Retiro ten years later. It was one of twelve battle scenes celebrating victories by Philip's armies.

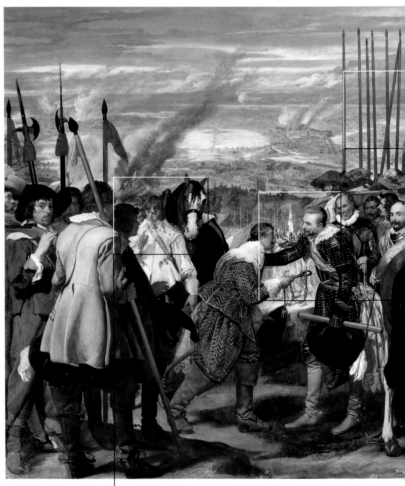

■ The spears, halberds, and the eyes of the defeated Dutch soldiers are lowered. The state of confusion is accentuated by dramatic contrasts between the horse, the white tunic of the soldier, and the fire that burns in the background.

■ The raised spears of the victorious Spanish soldiers set up a barrier that distances the background landscape, emphasizing the depth and creating a *trompe-l'oeil* effect. Particularly realistic are the oblique spears – the only interruption of the otherwise parallel lines of the composition; they accentuate the discipline of the triumphant battalion.

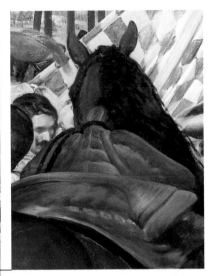

■ The Spanish horse is shown from the back, and is almost a mirror image of the Dutch horse. The two animals mark out a restricted space within the larger expanse of the battlefield and the town of Breda, where the historic event took place. The scene is less a conventional commemoration as a dynamic moment shortly after the end of a battle.

■ The face of the Marquis Spinola, who as head of the battalion from Flanders had won over the town of Breda, is scrupulously rendered by Velázquez, who had known the general during his journey from Barcelona to Genoa. He had probably sketched his features at the time. At the centre of the composition is the key of the city, symbol of surrender, handed over by the governor, Justin of Nassau. In the background the defeated soldiers march away.

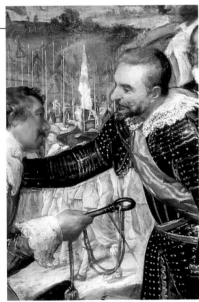

The royal collection

Before Charles V, Spanish royalty had never shown any genuine interest in art collection. Paintings, tapestries, and other artefacts served to decorate the royal residences, but since the court never stayed for any length of time in one place, these ornaments were continually moved, and the monarchs were more inclined to commission works they could donate to the chapels they founded. Furthermore, on the death of a ruler it was customary to sell the monarch's collections of art. Charles V was the first king to leave most of the works he had collected to the heir to the throne. This practice was to be adopted by later rulers, and Charles' son Philip II converted the palace into galleries to display the paintings. He was of the opinion that "if otherwise hidden they would lose their value which existed in the eyes of others and in the judgment that men of good sense and good imagination made of them". The setting up of a genuine collection came about when Philip II established his residence in Madrid: the Royal Palace collection nevertheless remained somewhat exclusive, compared with the one in the Escorial monastery. However, it was to be Philip IV who finally brought together an unrivalled number of works, surrounding himself with the finest artists and ordering his ambassadors and agents to buy works of art in foreign countries.

■ Below: Giorgione, *The Virgin and Child with St Anthony and St Roch*, 1505–10, Museo del Prado, Madrid. This painting came to Spain in about 1650 as a gift from the viceroy of Naples, Duke Medina de las Torres, who admired it greatly, hung it above a door in the Escorial.

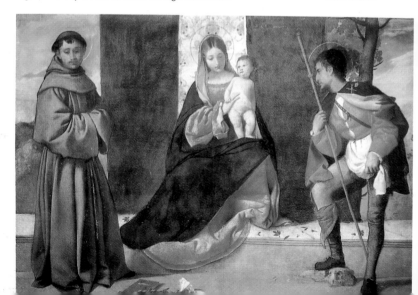

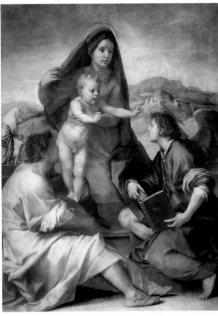

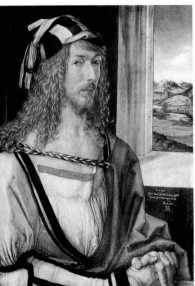

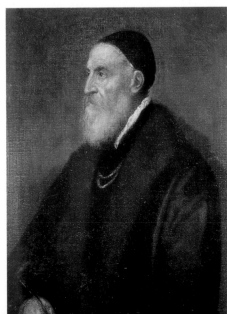

■ Left: Jan "Velvet" Bruegel, *Allegory of Sight*, 1617, Museo del Prado, Madrid. Sold to the Duke of Pfalz-Neuburg, this was later owned by the Duke of Medina de las Torres, and finally by the king.

■ Below: Andrea del Sarto, *Madonna della Scala*, 1515–20, Museo del Prado, Madrid. This work was another acquired by Cárdenas in 1649 for Philip IV from the English collection of Charles I.

■ Above: Albrecht Dürer, *Self-Portrait*, 1498, Museo del Prado, Madrid. This Dürer painting was bought for the Spanish monarchy at the auction of the collection of Charles I of England by the ambassador Cárdenas .

■ Right: Titian, *Self-Portrait*, c.1568, Museo del Prado, Madrid. Titian's self-portrait was bought by the Royal house for 400 florins at an auction of Rubens' possessions.

The works of the Torre de la Parada

From 1633 to 1636, when employed at the Buen Retiro palace, Velázquez also worked at the Torre de la Parada, the hunting lodge near El Pardo. Here, Philip IV had assembled many works by Rubens and his school, such as the paintings inspired by Ovid's *Metamorphoses*, along with others that were lighter in subject but still exceptional examples of still life and hunting scenes. Velázquez' responsibility was to provide the small palace with several portraits of the royal family in hunting costume and with their favorite animals, in the natural surroundings of the Sierra de Guadarrama. The result was astonishing: because he was not concerned with etiquette and could express himself with greater feeling than was normal for official portraiture, Velázquez succeeded in capturing the personalities of the royal family, without having to include excessive symbols of majesty. His stay was also an opportunity for him to study landscapes.

■ Castelo, the *Torre de la Parada*, 1637, Museo Municipal, Madrid. The hunting lodge was situated near Madrid, close to the Pardo mountains.

■ Right: Velázquez, *Philip IV as a Hunter*, 1634–36, Museo del Prado, Madrid. In the simple dignity and elegance of his hunting outfit, the king is confident enough of his position to dispense with any special symbolism to emphasize his superiority.

■ Below: Velázquez, *Philip IV Hunting Wild Boar*, c.1632–37, National Gallery, London. Horseriding and the hunting of wild boar were fundamental pastimes for the king.

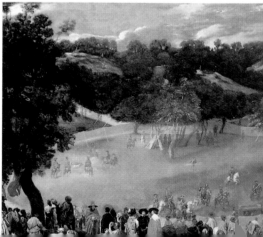

■ Velázquez, *Prince Baltasar Carlos as a Hunter*, 1635–36, Museo del Prado, Madrid. This is one of the painter's most charming works and perhaps the finest portrait of the prince, seen in all the fresh innocence of childhood. The little boy is shown with a Spanish gun-dog and a greyhound, visible only by its muzzle and paws.

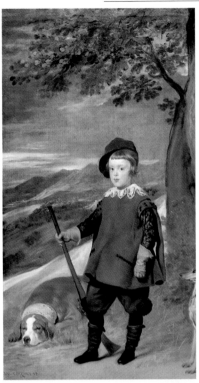

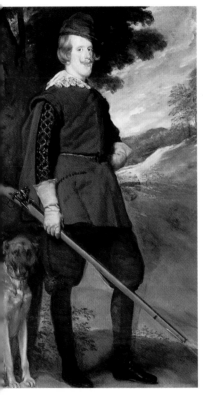

■ Right: Velázquez, *The Cardinal-Infante Don Fernando of Austria as a Hunter*, 1632–36, Museo del Prado, Madrid. The face of the cardinal-infante seems somewhat hard compared with the smooth serenity of his pose, the dog, and the background landscape.

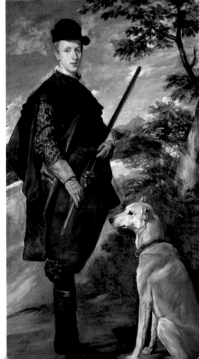

LIFE AND WORKS

Court entertainers

Thousands of people made up the court of Philip IV, including the nobility and other dignitaries, doctors, priests, administrative officials, and their servants. There were also the entertainers; the dwarfs and jesters or "buffoons", whose defects and deformities accentuated the beauty and wealth of the royal family and the nobility. These entertainers had been a feature of European courts for many years, and their portraits often appeared in their masters' collections. Velázquez painted six identified Court fools, dwarfs, and jesters, along with several other unnamed images. He portrayed them in fine detail with sensitivity and honesty, recognizing their humanity as well as their deformities. One particular work is enlightening: *The Buffoon Known as Don Juan of Austria*; the name of a general known for his military mistakes, and who became an ironic symbol of Spain's problems at the time. The jester was probably commanded to impersonate him.

■ Velázquez, *Prince Baltasar Carlos in the Riding School*, detail, c.1636, Wallace Collection, London. It is likely that this is Don Sebastián de Morra.

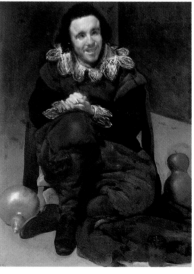

■ Velázquez, *The Buffoon Calabazas*, 1637–39, Museo del Prado, Madrid. Velázquez impressively captures the character of the man, with his vacant, squinting eyes and distorted smile. By his side is a spinning top – traditional symbol of folly.

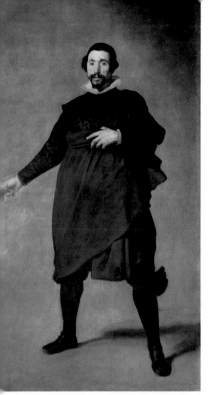

■ Velázquez, *Pablo de Valladolid*, 1633, Museo del Prado, Madrid. The subject of this masterpiece was a member of the court engaged to entertain the royal family. It was greatly admired both by Velázquez' contemporaries and by later artists.

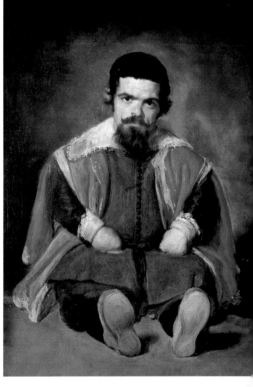

■ Velázquez, *The Buffoon Known as Don Juan de Austria*, 1636, Museo del Prado, Madrid. Velázquez paints the entertainer in a military pose, holding sword and baton, with armor strewn at his feet. The pose echoes and parodies heroic portraits of the time.

■ Above: Velázquez, *A Dwarf Sitting on the Floor*, c.1645, Museo del Prado, Madrid. Possibly a picture of Don Sebastián de Morra, this portrait of the bearded dwarf takes on a monumental appearance, accentuated by his foreshortened legs.

LIFE AND WORKS

Unfinished works, copies, and collaborations

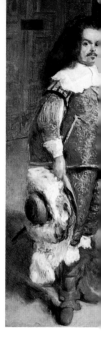

Little is known of the workshop of Velázquez, but it is thought that he did tutor a number of pupils in Madrid, and possibly also in Seville. He collaborated in Seville first with Herrera and later with Pacheco, and then struck out on an independent path as a painter, employing only a few collaborators, usually from his pupils. One of the best known was his servant Juan de Pareja, whom Velázquez taught to paint, and Juan Bautista Mazo, his official copyist, son-in-law, and heir to the coveted position of court painter. Mazo is credited with a number of copies of his master's work, and he has been attributed with completing some of the canvases that Velázquez started, although this is still debated. Velázquez' preparatory studies and incomplete work are interesting for the light they throw on his technique. However, retouchings or corrections to his known paintings are rare, a sign that the clear idea and foresight gained from preliminary work was followed through with great confidence.

■ Below: Velázquez, *Arachne (A Sibyl)*, 1644–48, The Meadows Museum, Southern Methodist University, Dallas. It appears that for this small work the artist worked from the same model, sketch, or idea as he used for the young woman in the *Fable of Arachne*.

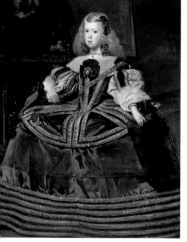

■ Juan Bautista Martínez del Mazo, *Portrait of the Infanta Margherita*, c.1660, Szépmüvészeti Museum, Budapest. This portrait was painted under the guidance of Velázquez, to whom it was for a long time attributed.

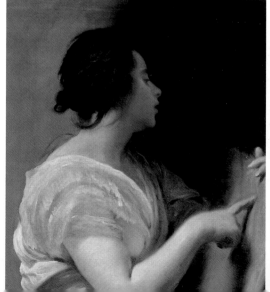

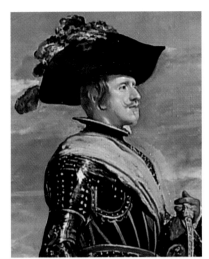

■ Velázquez, *Philip IV on Horseback*, detail, 1628–34, Museo del Prado, Madrid. There are a few clear signs of repainting on the chest and along the face of the king: these may be evidence of reworking of the composition by the artist himself, or they may be repairs to the damage caused by a fire at the Buen Retiro in 1640.

■ Above: Velázquez' workshop, *Don Antonio "el Inglès", Dwarf with Dog*, c.1675, Museo del Prado, Madrid. This is an obvious copy of Velázquez' subject matter and style.

■ Velázquez, *The Needlewoman*, National Gallery of Art, Washington DC. It is only possible to date this work from between 1640 and 1643. The head is the only finished part, although the rhythm of the hands is already masterfully sketched. It is a useful insight into the painter's method.

Christ on the Cross

Intended for the Convent of San Placido, this painting is now in the Museo del Prado, Madrid. Philip IV commissioned the work from Velázquez in about 1631. It is a bold and striking depiction of the crucifixion.

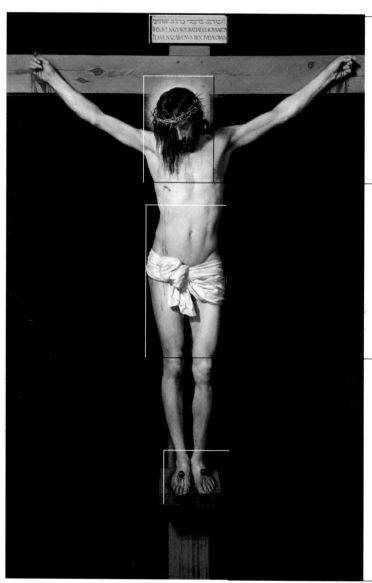

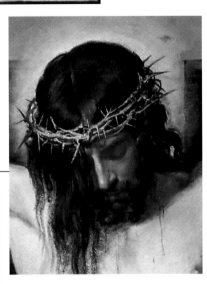

■ The uncommon choice of inscription reads "Jesus the Nazarene King of the Jews", which appears in three languages (Hebrew, Latin, and Greek), rather than the abbreviated form, "INRI".

■ Below: The construction of the "Apollonian" body, highlighted by the clear tones of the flesh in contrast with the dark background, corresponds to the canons of classicism that the artist employed after his visit to Italy.

■ The downcast head with the loose, long hair tumbling from the crown of thorns is the centre of the dramatic scene. The graphic details of the crown, face, and the droplets of blood are meticulously executed.

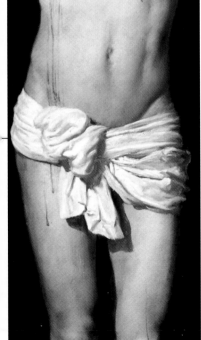

■ The feet are resting on a broad base, each with an individual nail. Velázquez' master, Francisco Pacheco, had been appointed as Censor of Paintings to the Spanish Inquisition, and laid down certain details, such as the number of nails that should be included.

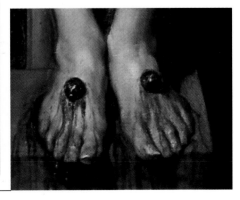

Velázquez, *Garden of the Villa Medici in Rome*, c.1650, Museo del Prado, Madrid.

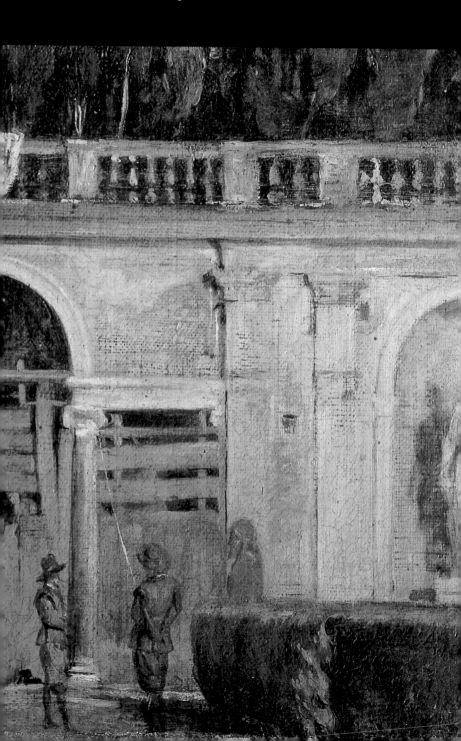

Abroad on king's business

In November 1648, Diego Velázquez again left Spain. This time he travelled on behalf of His Majesty on a visit to Pope Innocent X. His particular assignment was to acquire works of art, original paintings, and antique Greek and Roman statues from various places in Italy. He journeyed with Don Jaime Manuel de Cárdenas, who was sent to welcome in Trento the wife-to-be of the king, Mariana of Austria, daughter of the Emperor Ferdinand III and the Empress Maria, infanta of Spain. Landing at Genoa, he continued on to Milan. Uninvolved in the celebrations for the arrival of the future queen, Velázquez preferred to admire the excellent works of painting and sculpture, including Leonardo's *Last Supper* and "all the paintings and churches there are in that city" (Palomino). After a visit to Padua, he briefly travelled to Venice to revisit the masterpieces that had influenced him twenty years previously. From there, he went on to Modena and Parma, to purchase works by Coreggio. He again sought inspiration from the artists of the past. He was also able to purchase paintings by Tintoretto, as well as portraits by several other artists. In Bologna he met the well-known fresco painters Agostino Mitelli and Michelangelo Colonna, who he contacted to invite them to return with him to Spain.

■ Left: Illustration from C. C. Malvasia, *A Bolognese Painter*, published 1841, Bertarelli Collection, Milan. One assignment of Velázquez' second trip to Italy was to entice to Spain Italian artists; this was the reason for his meeting in Bologna with Agostino Mitelli.

■ Below: classical sculpture of Ariadne, Museo del Prado, Madrid. Philip IV, a noted art lover, wished to enrich his collections with statues that, according to Palomino, could be found in Rome "almost everywhere".

MALAGA

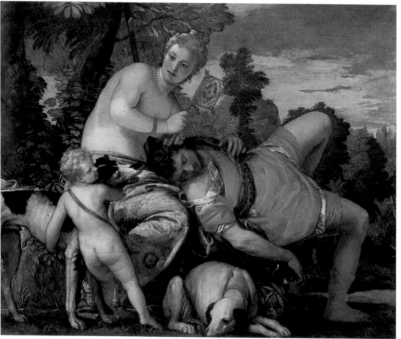

■ Valegio, engraving of Malaga, 17th century, Bertarelli Collection, Milan. Velázquez left Madrid in October 1648, together with a court official for convenience and security. He travelled from Granada to Malaga and set sail from there in January 1649.

■ Above: Veronese, *Venus and Adonis*, c.1680, Museo del Prado, Madrid. On the Venetian stage of his second visit to Italy, Velázquez acquired this work for the royal collections.

■ Right: Velázquez, *Portrait of Queen Mariana of Austria*, c.1652, The Meadows Museum, Southern Methodist University, Dallas. The young Mariana was chosen to become monarch and continue the Habsburg line in Europe.

95

Venus at Her Mirror

The only surviving female nude by Velázquez, (c.1651, National Gallery, London), this is generally known as the *Rokeby Venus*, as it was in the collection at Rokeby Hall, Yorkshire. The subject was rare in Spain and disapproved of by the Inquisition.

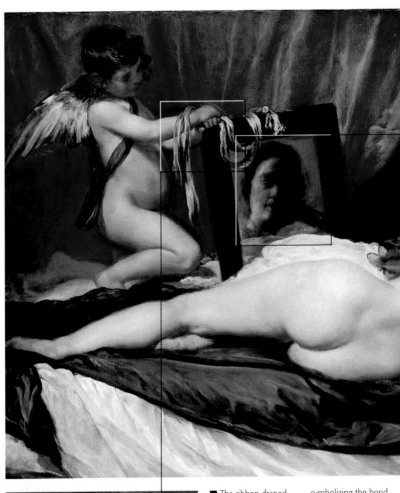

■ The ribbon draped over the wrists is not used for hanging the mirror but for symbolizing the bond between Venus and Cupid, Venus' son the god of love.

■ Venus was regarded as the most beautiful of gods. The blurred image in the mirror is a masterful study and a comment on the spectator's voyeurism – perhaps Venus is watching us watching her.

■ An immediate precedent was Titian's greatly admired *Venus at Her Mirror* (1555, National Gallery, Washington), which shows a variant of the reflected image. Here, the mirror is held side on by Cupid, while Venus faces the spectator.

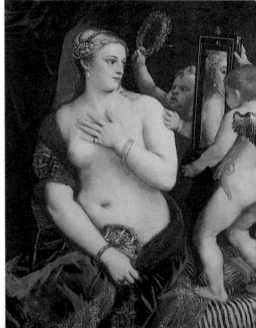

The portrait tradition in Italy

In Italy, during the 17th century, portraiture was a well-established genre. It had developed since medieval times through a range of significant examples, from the low-key presence of the donor within a devotional work to grand paintings of single individuals and family groups. Renaissance artists preferred to handle the subject with a half-length view in profile, which imitated the ancient classical formula for portraiture and set much store on an exact replica of the features. The background was only of relative importance, seldom symbolic, and always provided a color contrast to emphasize the face. The frontal portrait came to be adopted in the second half of the 15th century and was fully accepted by the 16th century. The scope of the picture was enlarged to include the hands, useful in further characterizing the sitter. Likewise the background, whether a landscape, an open window, or a domestic interior, contributed to this definition. It was during the second half of the 16th century, with the distinct personalities and works of Titian and Lotto, that new impetus was given to a form of portrait that looked inward to the character of the sitter and focused on symbolic and allusive meanings.

■ Below: Raphael, *Portrait of Angelo Doni*, 1506–7, Palazzo Pitti, Florence. Raphael's originality as a portraitist was his ability to combine harmoniously the precise physical features and expressive character of the face.

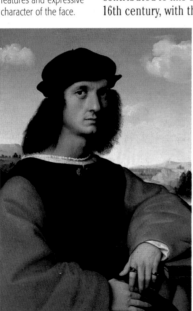

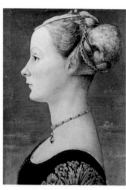

■ Pietro Pollaiuolo, *Portrait of a Gentlewoman*, 1460–70, Museo Poldi Pezzoli, Milan. The profile of the noble lady stands out from the background, highlighting the sharp features and the pearly white flesh.

■ Below: Ghirlandaio, *Portrait of Giovanna Tornabuoni*, 1488, Thyssen-Bornemisza Collection, Madrid. The subject's beauty is affirmed on the scroll: "If you, art, can also represent the character and the virtue, there cannot be a more lovely image on earth."

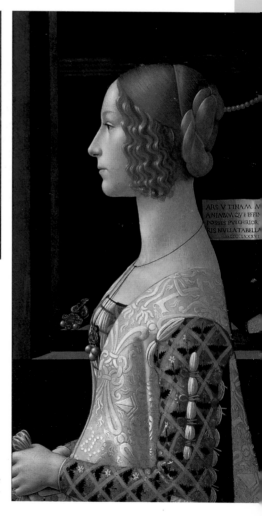

■ Above: Titian, *Portrait of Vincenzo Mosti*, c.1520, Galleria Palatina, Florence. Master of the art of portraiture, Titian breathed new life into his subjects.

■ Left: Lorenzo Lotto, *Portrait of Andrea Odoni*, 1527, Royal Collection, Hampton Court. A great portrait painter of the 16th century, Lotto was born in Venice and, like all his Venetian contemporaries, was influenced by Bellini.

99

Encounters with the Italian court

Unlike previously, Velázquez was now granted many opportunities to meet with members of the Italian nobility. He was able to travel to Florence, omitted in his previous trip, and then to Modena, where he won the favor of the duke. Here, he familiarized himself with the work of Correggio in the celebrated dome of the cathedral of Parma and various paintings by Parmigianino. Before arriving in Rome, at the papal court, he made a short diversion to Naples in order to meet the Count of Orñate, the viceroy delegated by Philip IV to assist the painter "in a large and generous manner" to ensure a successful outcome to his mission. During the first months spent travelling through the peninsula, he was in his role as collector and diplomat rather than painter: he studied the masters of the past in order to select worthy examples to bring back to the king, and he used his letters of presentation to introduce himself to the courts, not with a view to self-promotion but to discuss art and acquire masterpieces. With such important commitments, Velázquez had no time for his own painting, and completed nothing until he reached Rome in the spring of 1650.

■ Correggio, *Assumption of the Virgin*, 1526–30, dome of Parma Cathedral. Velázquez visited the cathedral to acqaint himself with Correggio's stunning dome.

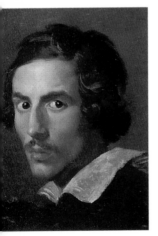

■ Gian Lorenzo Bernini, *Self-Portrait*, c.1623, Galleria Borghese, Rome. For Velázquez, Bernini was the only living artist of interest in Italy.

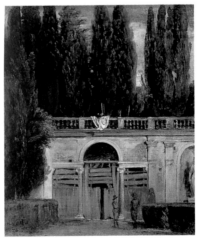

■ Left: Velázquez, *The Gardens of the Villa Medici in Rome*, c.1650, Museo del Prado, Madrid. A place frequented by Velázquez twenty years before, this tranquil landscape probably inspired him again during his second visit to Rome.

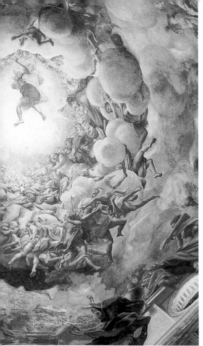

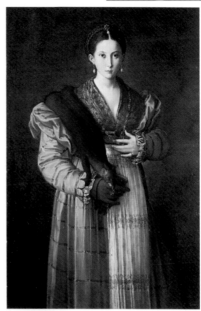

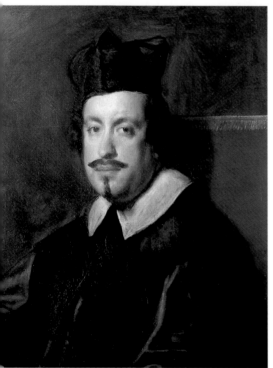

■ Above: Parmigianino, *Portrait of Anthea*, 1535–37, Galleria Nazionale di Capodimonte, Naples. Velázquez had the opportunity to admire several works by Parmigianino, including this superb example of an Italian 16th-century portrait.

■ Velázquez, *Portrait of Cardinal Camillo Massimi*, c.1650, Spanish Room, Kingston Lacy (The National Trust), Wimborne Minster, Dorset. The light is concentrated on the face of the cardinal, who was a friend of Velázquez. The harmony of the work is in the elements of the blue robe, the white collar, and the flesh tones of the face.

Juan de Pareja

Juan de Pareja was the assistant of Velázquez, who taught him the art of painting. He took him on his trip to Italy and painted him in Rome in 1650. This portrait is now in the Metropolitan Museum of Art, New York.

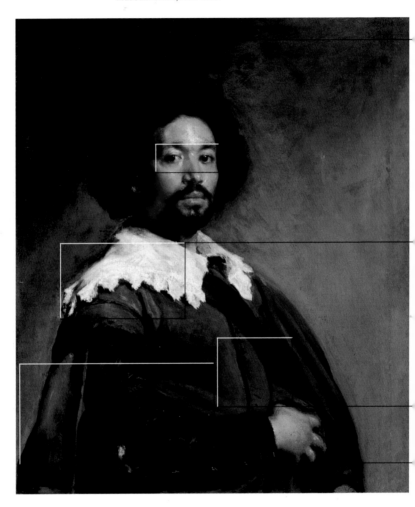

■ There is a pride and intensity in the eyes of Velázquez' assistant, who looks back at the artist, his body turned to the right.

■ Pareja's head is raised and highlighted, set off by the white ruffed Flanders collar.

■ Every part of the portrait shows attention to detail: a band of darker color crosses the lacing of the jacket. It is like a bandolier that accentuates the confident, almost military, attitude of the sitter.

■ The restricted palette adopted by the artist is extremely effective. Against a grey-green background, Pareja is portrayed in a subtle range of browns, greens, and blacks. The light brush marks on the sleeve define the velvet.

An extended visit

The status of court artist on a mission for the king allowed Velázquez enough freedom to prolong his trip abroad, despite the summons of the monarch in Madrid. During the two and a half years since his departure from Spain, he had spent about 18 months in Rome, where he had resumed his own painting. He completed ten portraits and several sketches, culminating in the masterpiece that immortalized Pope Innocent X. His warm reception in Rome encouraged him to contact Pietro da Cortona with the view of persuading him to move to Madrid, but the negotiations did not have a successful outcome. He was more fortunate, after lengthy insistence, with the Bolognese painters Mitelli and Colonna. During his time in Rome, he gained access to all the most renowned artistic circles, including membership of the Accademia di San Luca and the society of the Virtuosi at the Pantheon. Meanwhile, Philip IV again requested Velázquez' return to Spain.

■ Above: Giovanni Battista Falda, print of the Pantheon, 1686, Bertarelli Collection, Milan. In 1650, Velázquez' portrait of Juan de Pareja was exhibited. The success of this led the artist to gain access to the most important societies, such as the Virtuosi at the Pantheon.

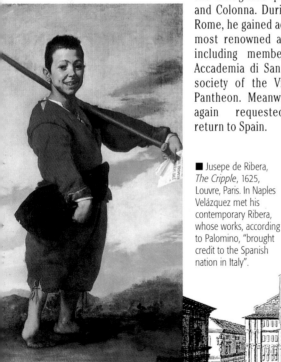

■ Jusepe de Ribera, *The Cripple*, 1625, Louvre, Paris. In Naples Velázquez met his contemporary Ribera, whose works, according to Palomino, "brought credit to the Spanish nation in Italy".

■ Below: 17th-century view of the Piazza Maggiore, Bologna. Velázquez stayed for some time in Bologna, both to admire the art works and to contact the fresco painters of the city.

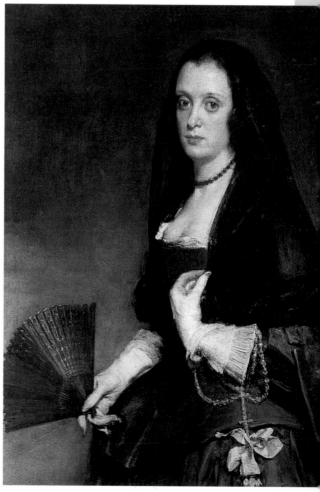

■ Velázquez, *Lady with a Fan*, c.1650, Wallace Collection, London. Some say that it was on account of this enigmatic lady – with her melancholy face and open fan – that the painter delayed his return to Spain.

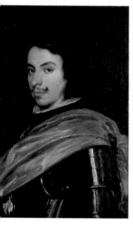

■ Above: Velázquez, *Portrait of Francesco II d'Este*, 1639, Pinacoteca Estense, Modena. Velázquez revisited this portrait, which he had completed on his first visit to Ferrara.

1649–1651

Portrait of Pope Innocent X

This justly famous portrait (Galleria Doria Pamphili, Rome) was painted in 1650; Velázquez accepted only a chain and medal in payment. He successfully combined the papal splendor of the office with the private character of the man.

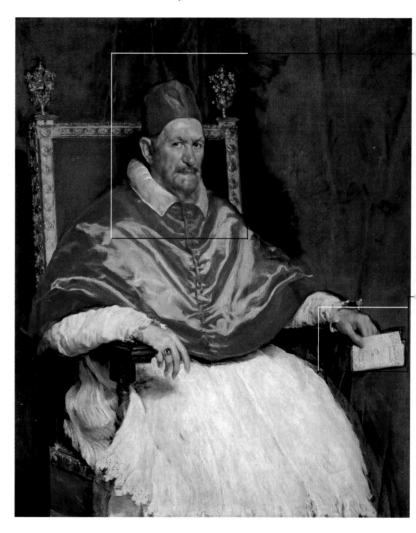

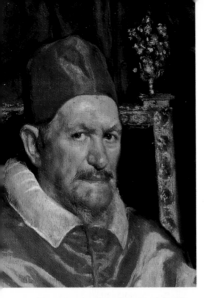

■ The harmony of the reds of the armchair, the curtain, the papal silk cap, and the short cape are reinforced by several touches on the face, particularly the severely pursed lips. The gold of the chair is in striking contrast to the reds, and the white collar has a pale red glow reflecting the cloth below.

■ Below: El Greco, *Cardinal Niño de Guevara*, 1596–1610, Metropolitan Museum of Art, New York. El Greco was one of the artists to whom Velázquez turned for reference: Palomino specifically mentions this portrait.

■ The hands are bathed in a yellowish light with purple touches. The folded paper is a letter of introduction bearing Velázquez' name.

■ Francis Bacon, *Study of the Portrait of Innocent X*, 1965, Private Collection. Bacon completed over 40 studies of Velázquez' Pope, and was concerned more with the dynamics of the figure than the portrait itself.

■ Raphael, *Portrait of Julius II*, 1512, National Gallery, London. Raphael painted the seated pope in three-quarter view. Here, as in the work of Velázquez, there are no superficial elements incorporated to reflect the subjects' status.

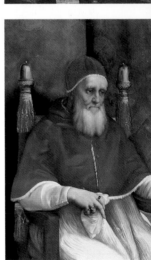

A glowing twilight

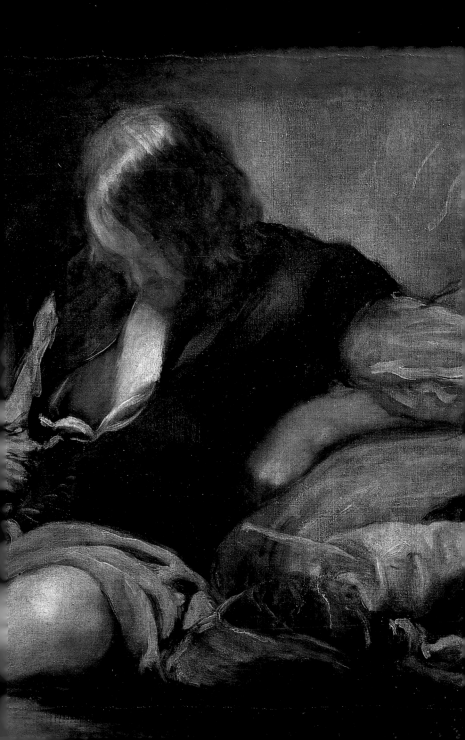

A kingdom in decline

The crises of the reign of Philip IV began with the rebellions of Catalonia and Portugal: the Catalan revolt, which occurred in the spring of 1640, was followed by the secession of Portugal at the end of the same year. In addition to these major events, there was later a conspiracy in Andalusia and uprisings in Naples and Sicily, which the monarchy managed temporarily to quell. These episodes had weakened the government of Olivares, who at that time had lost the support of virtually the entire ruling class of Castile. Olivares was stripped of his responsibilities, which led to the gradual collapse of the system of government he had so carefully organized. The king announced that he would govern in person, but in fact he had already planned to place his trust in a new prime minister, Luis de Haro, nephew of Olivares, merely perpetuating a political situation similar to that created by the count-duke. The second half of Philip IV's reign was beset, furthermore, by grave financial problems and a wave of heavy bankruptcies. The American colonies were a drain on the treasury, and the population was decimated by plague in 1642 and 1652. The new tax measures implemented made the government more and more unpopular.

■ Cardinal Richelieu, shown here in an engraving dating from 1651 (Bertarelli Collection, Milan) was a key figure in the struggle for European dominance. In 1635, he officially announced the beginning of hostilities between France and Spain.

■ Below: Juan Bautista Maino, *Capture of Bahia*, 1635, Museo del Prado, Madrid. The celebration of this military action was commissioned for the throne room of the Buen Retiro palace. Events in the New World contributed to the economic crisis.

■ Peter Paul Rubens, *The Count-Duke of Olivares*, Musées Royales, Brussels. The king dispensed with the services of his prime minister in 1643.

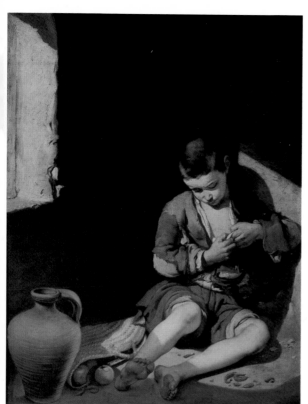

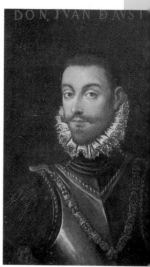

■ Bartolomé Esteban Murillo, *The Young Beggar*, c.1655, Musée du Louvre, Paris. From 1647 to 1662, the empire underwent four bankruptcies, condemning thousands more Spanish people to lives of poverty.

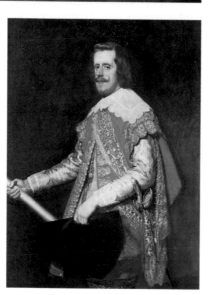

■ Right: Velázquez, *Portrait of Philip IV at Fraga*, 1644, Frick Collection, New York. In 1643, the artist had accompanied Philip IV during his campaign against the rebels, an episode that prefigured later crises.

■ Above: Anonymous, *Portrait of John of Austria*, second half of 16th century, Real Academia de la Historia, Madrid. The natural son of Charles V was governor of Flanders at the end of the 16th century. The actions in which he had participated – the wars against the Moors, and the battle of Lepanto – were by this time part of Spain's past greatness.

A lighter approach

Velázquez painted several characters from mythology and antiquity for the Torre de la Parada, the hunting lodge for which the king had also commissioned Rubens to paint a number of mythological fables. Compared with their colleagues in the rest of Europe, Spanish artists devoted themselves far less enthusiastically to subjects derived from myth and ancient legend. This is demonstrated by the fact that Velázquez contracted foreign artists, who were more inclined to take such themes seriously, to help decorate the lodge. Spanish literature of the Golden Age expressed a decidedly satirical attitude towards mythology. Lope de Vega and Cervantes had no hesitation in attributing to the gods the likenesses of ordinary men and women, and Velázquez himself painted mythological figures stripped of all grandeur. It is probable that, conditioned by the atmosphere of the Counter-Reformation, artists worked in this way order to distance themselves from paganism. In terms of allegory, the myth could either have a moral significance or could remain a charming fable, intended purely for entertainment value.

■ *Ares Ludovisi*, Museo Nazionale di Arte Antica, Rome. Velázquez' version was modelled on Classical ancient sculpture; although inspired by the *Ares Ludovisi*, it does not reflect its monumental heroism.

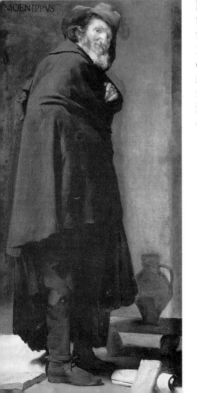

■ Velázquez, *Menippus*, c.1639–41, Museo del Prado, Madrid. This work may have been completed in the last years of the painter's life, given its technical mastery.

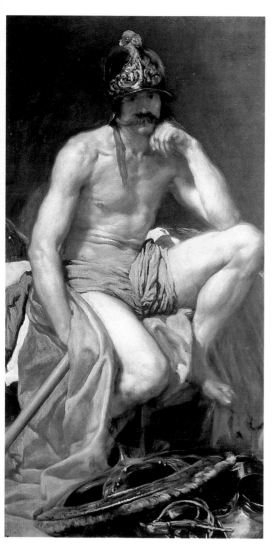

■ Below: Jusepe de Ribera, *Aesop*, 1630, Museo del Prado, Madrid. The Greek fable-teller is shown as a comic actor, rather than as a Christian saint or prophet.

■ Velázquez, *Mars*, 1639–41, Museo del Prado, Madrid. Unlike his usual portrayal as the proud god of war, Mars here appears as a pensive, betrayed lover, the symbols of his power scattered around.

■ Velázquez, *Aesop*, c.1639–40, Museo del Prado, Madrid. This work shares the anti-heroic interpretation of Ribera's *Aesop*. The figure had also been adopted by Italian artists such as Luca Giordano.

A new appointment

On his return to Madrid in June 1651, Velázquez brought with him the paintings and sculptures he had purchased on behalf of the king, intended for the adornment of the new Alcázar, where work had been going on for the last two years. The king was so pleased with his painter's achievements that he decided to appoint him *aposentador mayor* – Grand Marshal of the Palace – in June 1652. He was first proposed for this post by the royal council, in preference to other important court officials and in spite of the veto of five members of the commission. Now the artist formed part of the high court hierarchy and his responsibilities in the palace grew: like a true major-domo immersed in the running of court affairs, he had to concern himself with the movements of the king and his retinue, organize accommodation, attend to the wardrobe, the tableware, and the decorations for ceremonies and feasts of every kind, and see to points of protocol. In 1656, among his various duties, was the task of supervising the hanging of various paintings in the Escorial. Even though all this took priority over his painting activities, Velázquez still completed works such as the *Fable of Arachne* and the four mythological canvases for the rooms of the new palace.

■ *View of the Alcázar of Madrid*, Bertarelli Collection, Milan. The decoration of the Alcázar was the principal reason for Velázquez making his second voyage to Italy.

■ C. C. Malvasia, engraving of Michelangelo Colonna, *Bolognese Painters*, 1841, Bertarelli Collection, Milan. In addition to securing paintings and sculptures, Velázquez succeeded in bringing certain artists to Spain, including Colonna, who worked at the royal palace.

■ Velázquez, *Mercury and Argus*, 1659, Museo del Prado, Madrid. This is the only one of four paintings on mythological subjects that was rescued from the 18th-century fire in the Alcázar. It shows how strongly Velázquez was influenced by Italian art.

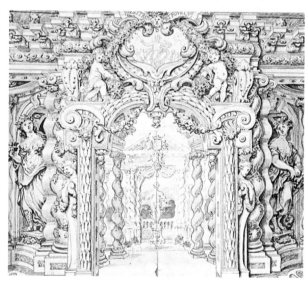

■ Left: Francisco Rizi, *Decorations for the Royal Festivities*, Biblioteca Nacional, Madrid. The duties of the *aposentador* also included that of attending and directing the organization of great celebrations.

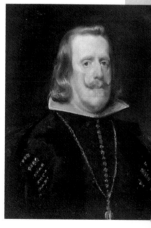

■ Velázquez, *Portrait of Philip IV*, National Gallery, London. The king eventually welcomed his painter back to court and soon gave him additional responsibilities.

115

Pictures within pictures

Spanish painters of the Golden Age, including Velázquez, often adopted the device of the "picture within a picture" when representing interiors. This was not only useful for creating new space inside an area already established, but also an element that could be charged with symbolic and allusive meaning – symbolism was becoming increasingly important in painting. The Spanish artists were by no means the first to employ the "picture within a picture" device; it was first employed in the exterior views that some 15th-century painters introduced into enclosed surroundings to convey a sense of space. In the 17th century, Flemish artists produced many works of apparent realism that included visual illusions, puzzles, and hidden symbolism. At the same time, the ambiguity between realism and illusion characterized the 17th-century theatre, which put on works with "scenes behind the scenes", enabling new sub plots and extra dimensions to be woven into the main narrative.

■ Zurbarán, *The Refectory of the Carthusians*, mid-17th century, Museo de Bellas Artes, Seville. The sermon that St Hugh preaches to the Carthusians is reinforced by the subject-matter of the picture hanging on the wall, which shows the Virgin and Child in the Flight to Egypt and the Baptist in the Desert.

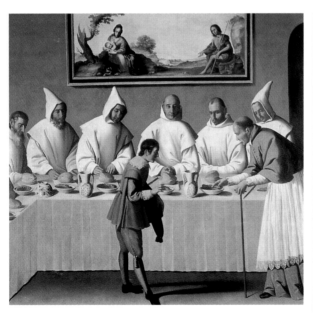

■ Above: Velázquez, *Christ in the House of Martha and Mary*, 1619-20, National Gallery, London. This early work contains within it a mirror reflecting a scene of Jesus and Mary.

■ Right: Jan Vermeer, *Young Woman Standing at a Virginal*, c.1672–73, National Gallery, London. Paintings of a landscape and, in its allusion to feminine innocence, Cupid are included in this Vermeer.

■ Left: Jan van Eyck, *The Arnolfini Marriage*, 1434, National Gallery, London. This famous work contains a mirror and an enigmatic reflection.

■ Jan Vermeer, *The Music Lesson*, 1662–64, Buckingham Palace, London. Here, the mirror above the harpsichord shows the face of the young player, but also reveals the unobtrusive presence of the artist, who is painting the reflection of the base of his easel. The theme of harmonious love is echoed by the painting of *Caritas romana* in the right background.

117

The Fable of Arachne

This work, also known as *The Spinners* (Museo del Prado, Madrid), was painted in about 1657. Light is the main element of this masterpiece, which is regarded as one of the most animated of Velázquez' works.

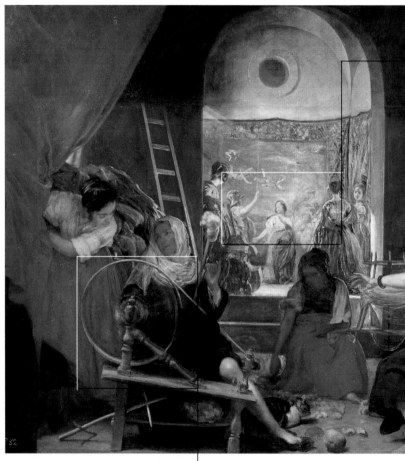

■ The spokes of the spinning wheel cannot be seen, since it whirls at such a speed. The background and the hand turning the wheel are just a blur of colour. The visual representation of movement is remarkably modern, and is among the many touches of bold originality in this complex masterpiece.

■ The tapestry hanging on the rear wall depicts Titian's *The Rape of Europa,* while in front of it are the figures of Pallas and Arachne, along with three women and a cello, possibly representing the Arts.

■ Below: Peter Paul Rubens, *The Rape of Europa*, 1628, Museo del Prado, Madrid. Titian's well-known masterpiece – copied here by Rubens – would have been immediately identifiable at the time.

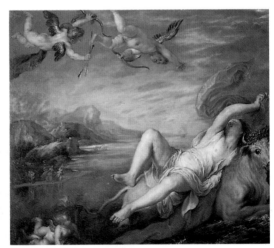

■ Velázquez may have been influenced by these Michelangelo figures in the Sistine Chapel for his portrayal of the two women weaving.

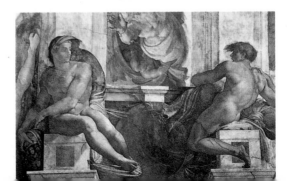

LIFE AND WORKS

Masterpieces for the royal family

During the last years of his life, Velázquez was obliged to restrict his activities as a painter because of his more pressing responsibilities at the palace. Difficulties in finding sufficient time to paint led him, possibly, to resort to collaboration, but it did not prevent him completing some beautiful portraits for the royal family using particularly elegant brushwork and exquisite color application. In addition to several portraits of the young queen and the king, shown progressively older and preoccupied by state affairs, the masterpiece of those years was undoubtedly the painting once called *The Royal Family*, but today better known as *Las Meninas*, after the attractive young maids of honor on either side of the infanta Margarita. It was during these years that Velázquez painted some particularly interesting portraits of small children, in which he expressed their innocent charm mingled with the vein of melancholy that is sometimes present in childhood.

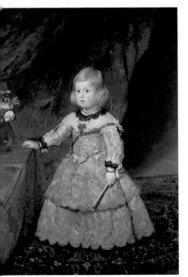

■ Velázquez, *The Infanta Margarita*, 1653–54, Kunsthistorisches Museum, Vienna. This was the first portrait of the young Margarita, who at three years of age already displays the symbols of her rank.

■ Velázquez, *Las Meninas*, detail, 1656, Museo del Prado, Madrid. The lively, crowded scene of Velázquez' most famous work revolves around the infanta Margarita.

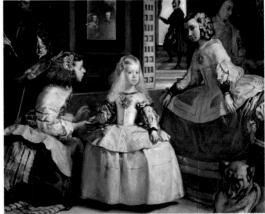

■ Left: Velázquez, *Mariana of Austria*, 1652–53, Museo del Prado, Madrid. A fine pictorial rendering of the young queen who married her uncle when barely fifteen, full of aristocratic dignity.

■ Below: Velázquez, *The Young Infanta Margarita*, Museo del Prado, Madrid. The daughter of Philip IV and Mariana of Austria, second wife of the king, was portrayed by Velázquez in 1659.

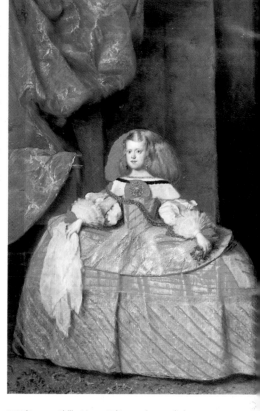

■ Velázquez, *Philip IV with a Lion at His Feet*, 1652–54. Museo del Prado, Madrid. Often seen as the companion work to the portrait of Queen Mariana, the attribution of this work to Velázquez is nonetheless debated. The shining armor projects the royal figure into the foreground, and the lion, sketched in at his feet, is a traditional symbol of majesty and strength.

121

Las Meninas

This, the most famous work by Velázquez (Museo del Prado, Madrid), was completed in 1656. It represents the infanta Margarita, the only child of Philip IV and the new queen of the artist's studio.

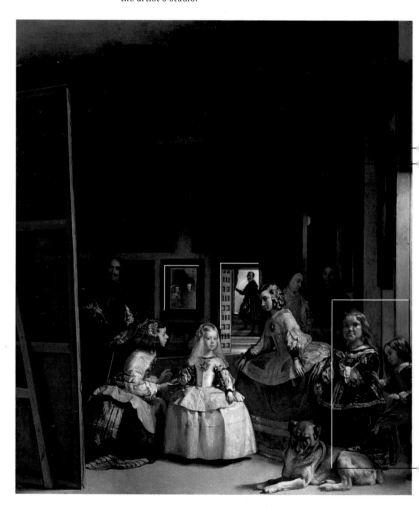

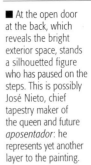

■ Reflected in the mirror are the images of Philip IV and Mariana. They are somewhere in the room, and are possibly the subjects of the portrait. The device is reminiscent of the earlier *Christ in the House of Martha and Mary*, and again adds an extra dimension to the work.

■ At the open door at the back, which reveals the bright exterior space, stands a silhouetted figure who has paused on the steps. This is possibly José Nieto, chief tapestry maker of the queen and future *aposentador*: he represents yet another layer to the painting.

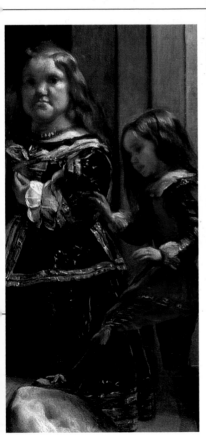

■ Margarita is accompanied by her retinue; not only the *meninas* but also the dwarfs. The attitude of Nicolás, who is holding the docile mastiff, indicates his familiarity with those around him, as if he were accustomed to be present at Velázquez' portrait sessions. The impression given is of an actual event – a scene brought about by chance and captured by the artist.

The knighted painter

D uring the long years he spent at court, Velázquez had nurtured a desire for noble recognition. Discussion as to whether painting should rank as a craft or an art had spurred the competitive instinct, and both he and his colleagues were eager to have their activity recognized for its true intellectual and creative worth. Long in service with the king, Velázquez was not content to remain as the court artist, even with his additional responsibilities. His greatest aspiration now was to belong to the knightly Order of Santiago, which still precluded painters and their families, in addition to anyone engaged in manual labor. Because he could not fully establish his noble origins, the king arranged for a papal dispensation to assist him: and on June 12, 1658, the painter was made a knight. Two years later, having returned to Madrid from the Isle of Pheasants in Northern Spain, where the peace between France and Spain was formalized, Velázquez died following a short illness on August 6, 1660. His funeral, celebrated with great pomp the next day, was a final affirmation of the high rank he had achieved.

■ Cesare Ripa, *Rivalry*, from the *Iconologia*, 1593. There was much rivalry between the noblemen at Philip IV's court.

■ Juan Bautista Martínez del Mazo, *The Painter's Family*, c.1659, Kunsthistorisches Museum, Vienna. Velázquez was protective of his position in court and avoided surrounding himself with potential rivals. After his death, his son-in-law assumed the post of court painter.

ALEXANDER VII.......CHISIVS SENEN·
·PONTIFEX........MAXIMVS·
CREATVS DIE VII........APRILIS MDCLV·

■ The intervention of pope Alexander VII, left, who issued a special bull to waive the requirements of nobility, was necessary for the painter to be nominated to the knightly order.

■ Below: The cross of Order of Santiago was the recognized sign of noble birth. There is a story that it was added by the king, who personally painted it on the tunic of the artist, as shown in *Las Meninas*.

■ The most important undertaking for the new knight was the supervision of the engagement of the infanta Maria Theresa to Louis XIV of France in June 1660. This put a seal on the Peace of the Pyrenees, ending hostilities between the two countries. Velázquez himself appears on the tapestry, below, behind the infanta.

BACKGROUND

The contemporary scene in Spanish painting

Apart from Juan de Pareja and Juan Bautista Martínez del Mazo, who both lived and worked closely with Velázquez, the very individual styles of Seville did not appear to have much impact upon the slow development of art in the rest of Spain. In Madrid, among the active painters of the time, were Carducho, Cajés, Nuñes de Valle, Fra Juan Rizi, Pereda, and Antonio Leonardo, masters associated with the tradition of early naturalism and whose traditional methods contributed little that was new. Francisco Rizi (brother of Juan) and Juan Carreño de Miranda were, however, figures of greater prominence. The former, among the most gifted artists of his time, was the disciple of Carducho, from whom he inherited a method of drawing in the Tuscan tradition: rapid execution, deep and contrasting color, and dynamic composition reminiscent of Rubens. Outside Madrid, naturalism flourished in Valencia with Jacinto Jeronimo Espinosa, notable for tenebrism, while Zurbarán was active in Seville. In the second half of the 17th century, Spanish painting would witness a radical transformation; a change of direction from naturalism towards a dynamic Baroque style, colorful and decorative in the manner of Rubens and Flemish painting, echoing the sumptuousness of earlier Venetian art.

■ Juan de Espinosa, *Still Life*, c.1650, Musée du Louvre, Paris. A medley of exotic objects surrounds the bunches of grapes.

■ Below: Pedro Orrente, *The Supper at Emmaus*, first half of 17th century, Szépmüvészeti Museum, Budapest. After a stay in Italy, Orrente, known as the "Spanish Bassano", nurtured a style very close to that of the Venetian masters.

■ Above: Francisco Rizi, *Auto-da-fé*, 1680, Museo del Prado, Madrid. Measured and restrained in style, Rizi's colors were influenced by the Venetian school.

■ Right: Pedro Nuñes de Valle, *The Waterseller*, c.1661, Museo de Bellas Artes, Seville. Children were popular subjects in Spanish painting.

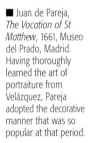

■ Juan de Pareja, *Baptism of Christ*, Museo del Prado, Madrid. After the death of his master, Juan de Pareja became more influenced by traditional Italian painting.

■ Juan de Pareja, *The Vocation of St Matthew*, 1661, Museo del Prado, Madrid. Having thoroughly learned the art of portraiture from Velázquez, Pareja adopted the decorative manner that was so popular at that period.

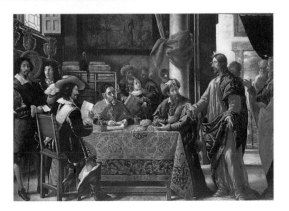

The indelible mark

The painters of the generation that immediately followed Velázquez were known mainly for their diverse palettes and their handling of particular genres, for example that of the official portrait. Their true worth was not recognized until the end of the 18th century, thanks to the engraved copies of Francisco Goya and Antonio Salvador Carmona. The striking feature of Velázquez, however, who had no genuine rivals in Spain, was, primarily, the modernity of his works. Goya studied them attentively, translated them into engravings, and used them as models for his own official portrait of the family of Charles IV. Obviously greatly influenced by *Las Meninas*, he placed himself in the composition in the act of painting, capturing the expressions of the children with all the skill and insight of Velázquez in his rendering of the infanta Margarita. Later, the same masterpiece was to impress Pablo Picasso, who visited the Prado and copied works by Velázquez in 1897. Picasso made a special study of *Las Meninas* in 1957, eventually completing sixty paintings inspired by the royal family scene, adapting the work and intensifying the relationship between the forms.

■ Pablo Picasso, *Las Meninas*, August 17, 1957, Museo Picasso, Barcelona. Picasso examined the composition of the work and the relationship between the figures by breaking down the painting to its component parts.

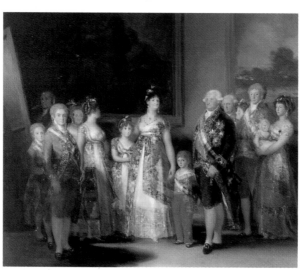

■ Francisco Goya, *The Family of Charles IV*, Museo del Prado, Madrid. After having engraved *Las Meninas* in 1778, Goya portrayed the royal family visiting his studio, inserting himself within the scene.

■ Below, left: Juan Carreño de Miranda, *Portrait of Charles II*, 1673, Musée des Beaux Arts, Valenciennes. The twelve-year-old final ruler of the house of Austria is depicted within a hall of mirrors with a delicacy that is reminiscent of Velázquez' work.

■ Below: In the 1960s, the Equipo Cronica group adopted the works of Velázquez with the aim of instigating political debate: the figures of Velázquez (here the Count-Duke de Olivares) were used to condemn the authoritarianism of Franco's regime.

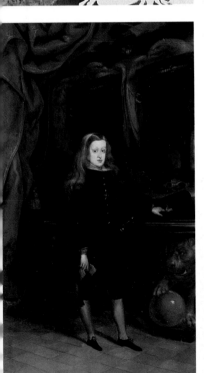

■ Right: Bartolomé Esteban Murillo, *Man with a Lace Ruff*, 1675, Museo del Prado, Madrid. Here, the subject's pose, with his hand on the table as a sign of power, and the darkness of the setting hark back to Velázquez' first portraits of the Count-Duke de Olivares.

Portrait of Philip IV

This is one of the last, if not the very last, portrait by Velázquez of the king (Museo del Prado, Madrid), painted between 1655 and 1657. The artist represents him with little sign of the illness that affected him, or of his advanced age.

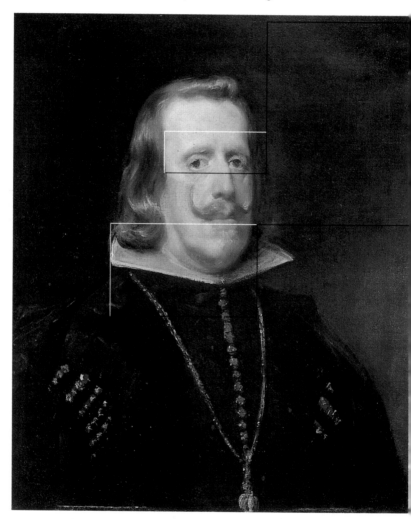

■ The artist is highly respectful of the sovereign, who retains his majesty, yet he renders realistically the look of a weary man at the end of his reign.

■ Philip's white collar protrudes from below his curls: other contemporary portraits show the king with a double chin – Velázquez is much more flattering.

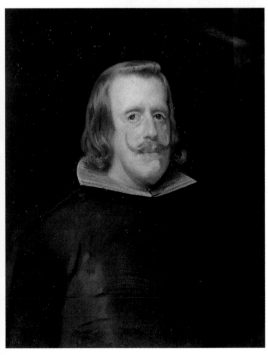

■ In 1653, Philip IV had written: "It is nine years since I had any portrait, and I feel little inclined to subject myself to his phlegm nor to witness myself growing older." The expression of the king is slightly sorrowful, compared to earlier portraits.

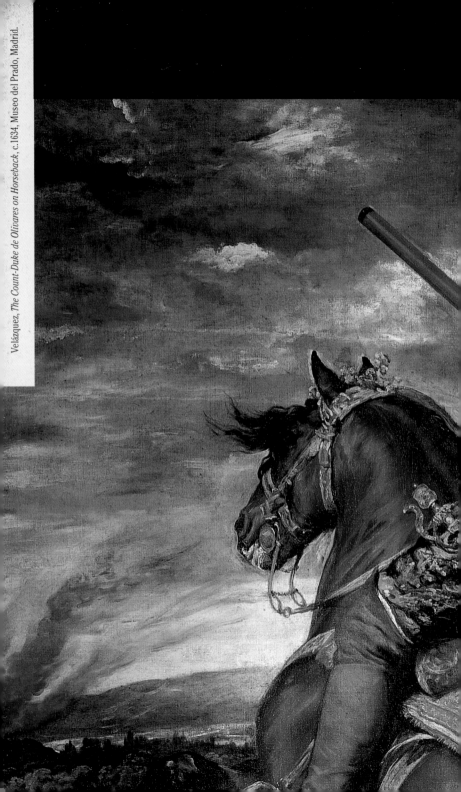

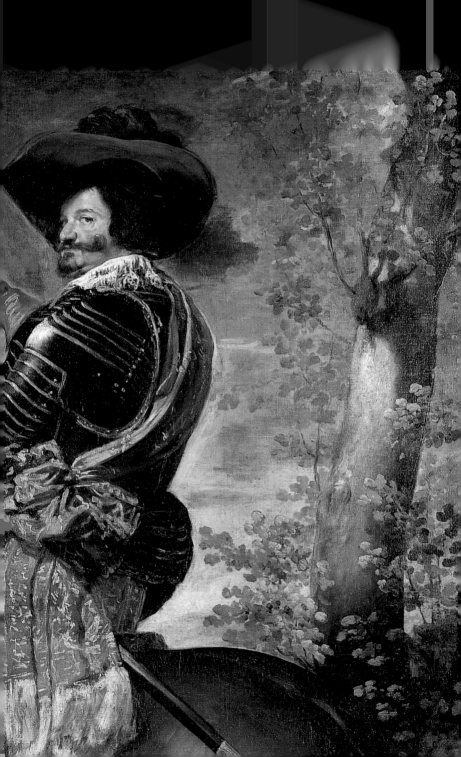

■ Velázquez, *Three Musicians*, 1617–18, Staatliche Museen, Gemäldegalerie, Berlin.

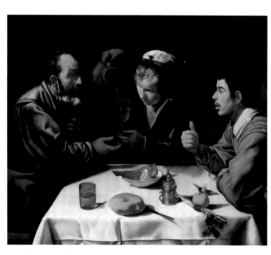

■ Velázquez, *The Peasants' Meal*, 1618–19, Szépmüvészeti Muzeum, Budapest.

■ Velázquez, *The Supper at Emmaus*, c.1620, National Gallery of Ireland, Dublin.

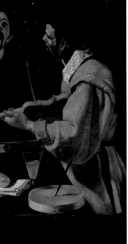

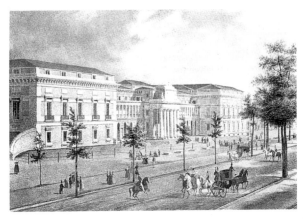

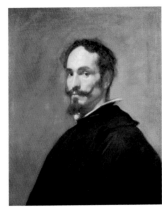

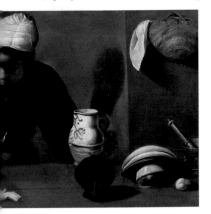

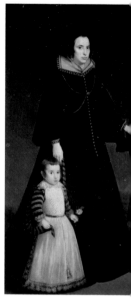

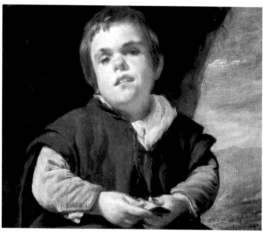

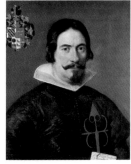

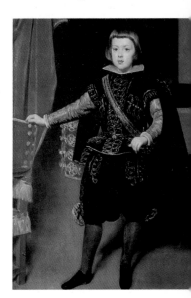

■ Velázquez, *Portrait of Queen Isabel*, 1631–32, Private Collection, New York.

■ Velázquez and pupils, *Portrait of Prince Baltasar Carlos*, c.1640, Kunsthistorisches Museum, Vienna.

Note

All the people mentioned here are artists, intellectuals, politicians, and businessmen who had some connection with Velázquez, as well as painters, sculptors, and architects who were contemporaries or active in the same places as Velázquez.

■ Caravaggio, *St Matthew and the Angel*, 1602, San Luigi dei Francesi, Rome.

Barberini, Francesco
(1597–1679), cardinal, nephew of Pope Urban VIII. A very cultured, discriminating man, he built a superb palace in Rome that accommodated priceless works of art. The abuses perpetrated by the Barberini family aroused so much hatred that he was compelled, on the death of his uncle, to seek refuge in France until Innocent III allowed him to return and reclaim his confiscated possessions, p. 56.

Bernini, Gian Lorenzo
(Naples 1598–Rome 1680), sculptor, architect, and painter. His many activities (he was also a stage designer, a playwright, and an inventor of machines and gadgets) took place in Baroque Rome, particularly at the papal court. Bernini made a major contribution to the setting up of this court, pp. 54, 100.

Pedro de Caldarón de la Barca (Madrid 1600–81), dramatist and poet. Author of about 120 plays, both religious and secular in subject, many unique in their radical ideas. He was among the greatest

exponents of European culture in a period that saw the decline of Habsburg Spain, p. 32.

Cano, Alonso (Granada 1601–67), sculptor, architect, and painter. He worked with the young Velázquez in Pacheco's workshop and performed various duties at court, p. 68.

Caravaggio, properly Michelangelo Merisi (Milan 1571–Porto Ercole 1610), painter. His revolutionary work, characterized by a vivid representation of reality and a technique that brought out strong

■ Vicente Carducho, *St Francis of Assisi and the Immaculate Conception*, 1632, Szépművészeti Museum, Budapest.

■ Francisco Goya, *The Crockery Seller*, 1779, Museo del Prado, Madrid.

contrasts between light and dark, had a profound influence on his contemporaries and on later generations of artists, pp. 40, 54.

Carducho, Vicente (Florence c.1576–Madrid 1638), painter and treatise writer. Italian by origin, he was the most influential painter at the court of Madrid prior to the arrival of Velázquez, who replaced him as the king's painter. His theoretical work, *Diálogos de la pintura*, was the most important of its time in Spain, pp. 11, 74, 126.

Charles V of Habsburg (Gand 1500–58), was Charles I, King of Spain, and became Emperor of the Holy Roman Empire in 1519. During the first half of the 16th century, he ruled an enormous territory over which "the sun never set". His abdication, in 1556, and the division of his dominions between his son Philip II and his brother Ferdinando, marked the failure of his plan for a universal empire, pp. 8, 9, 10, 31, 37, 49, 72, 82, 86.

Cervantes, Saavedra Miguel (Alcalá de Henares 1547–Madrid 1616), novelist and dramatist. Experimenting with new and interesting ideas but without distancing himself from tradition,

he began writing in the reign of Philip II and reached maturity with *Don Quixote*, his masterpiece. It was one of the most inventive and remarkable novels in European literature.

Góngora y Argote, Luis de (Córdoba 1561–1627), poet. One of the most influential literary figures of the age – his diverse and Baroque popular work was imitated and exaggerated by lesser poets. These imitators devalued his reputation somewhat, but it was restored in the 20th century.

Goya y Lucientes, Francisco (Fuentedetodos, Saragossa 1746–Bordeaux 1828), painter. Trained in the tradition of 18th-century painting, he followed the example of Velázquez, and turned his back on academic rigidity to paint with absolute freedom of inspiration and execution. He recorded a full range of contemporary events, from the most picturesque aspects of common life to portraits of monarchs and scenes of the brutality of the war that erupted in Spain after the Napoleonic invasion, p. 128.

Greco, El, properly Domenikos Theotokópoulos (Candia 1541–Toledo 1614), painter.

Originally from Crete, after a long stay in Venice, where he worked beside Titian and was influenced by Tintoretto, he moved to Spain, and lived in Toledo until his death. His works, predominantly religious in character, are characterized by a visionary vein of fantasy that is expressed in sharp contrasts of color and light, and bold, tormented figurative composition.

Herrera (the Elder), Francisco (Seville 1589–Madrid 1657), painter and engraver. He was a specialist in genre scenes and still lifes, pp. 12, 16, 22.

■ Gian Lorenzo Bernini, *Ecstasy of St Teresa*, c.1647–52, Santa Maria della Vittoria, Rome.

■ El Greco, *Burial of Count Orgaz*, 1586, San Tomé, Toledo.

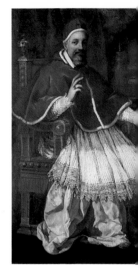

Innocent X, Giovanni Battista Pamphili (Rome 1574–1655), pope. Elected in order to provide an antidote to the pro-French tendencies of the Vatican, he always exhibited goodwill towards Spain, pp. 104, 106–107.

Martínez del Mazo, Juan Bautista (Cuenca c.1612–Madrid 1667), painter. Son-in-law and collaborator of Velázquez, he was an able copyist as well as a painter of Roman landscapes and views, pp. 49, 73, 88, 124.

Mitelli, Agostino (Battedizzo, Bologna 1609–Madrid 1660), architect and painter. A brilliant exponent of perspective and decoration in the Bolognese

tradition, he worked after 1658 at the court of Philip IV, pp. 94. 104.

Murillo, Bartolomé Esteban (Seville 1618–82), painter. He painted large devotional canvases and altarpieces with biblical scenes in a style full of elegance and idealized beauty. He also painted rustic scenes, in a range of delicate and subtle colors. This was a style greatly appreciated by his contemporaries and also in the 18th and 19th centuries, pp. 10, 111, 128.

Olivares, Gaspar de Guzmán y Pimental, count-duke of (Rome 1587–Toro, Zamora 1645), politician. He was the prime minister and favorite of Philip IV, but the failure of his policies, based on fiscal legislation and centralization, led to separatist uprisings and induced the king to distance himself from power, pp. 28, 29, 44–5, 110, 129.

Pacheco, Francisco (Sanlùcar de Barrameda 1564–Seville 1644), painter and writer. Father-in-law and master of Velázquez, his fame arose principally from his treatise *The Art of Painting*, pp. 16–17, 28, 56, 62.

Palomino de Castro y Velasco, Antonio Aciscio (Bujalance 1655–Madrid 1726), painter and writer. He painted large decorative cycles but is remembered chiefly for his written works: his *Museo pictórico y escala óptica* (1715–24) was a fundamental source of information on Spanish 16th–18th-century painting, pp. 16, 17, 94.

Philip II (Valladolid 1527–Escorial, Madrid 1598), King of Spain and Portugal. He inherited from his father Charles V the crowns of Castile (with the colonial American empire), Aragon, Sicily, and Naples, plus the duchy of Milan and the Netherlands. He initiated a policy of European and

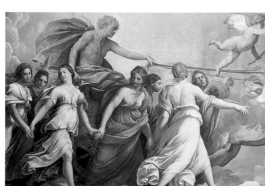

■ Pietro da Cortona,
Portrait of Urban VIII,
c.1626, Pinacoteca
Capitolina, Rome.

■ Bartolomé Esteban
Murillo, *The Pool
of Bethesda*, 1671–73,
National Gallery, London.

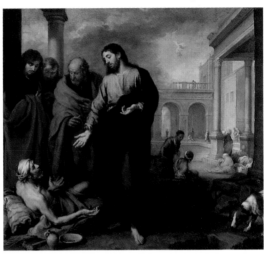

world colonization, imposing
religious and administrative
uniformity throughout his
domains, pp. 29, 30, 31, 36,
48, 72, 82.

Philip III (Madrid 1578–1621),
King of Spain, Naples and
Sicily, and, as Philip II, of
Portugal. His decree to expel
the Moors hastened the
decline of the Spanish
economy, pp. 28, 29, 31,
36, 74.

Philip IV (Valladolid
1605–Madrid 1665), King of
Spain, Naples and Sicily, and,
as Philip III, of Portugal. Patron
and cultivator of the arts, he
entrusted his government to
his favorites. During his reign,
Spain's irreversible decline
set in, pp. 10, 28, 29, 30, 31, 35,
42, 64, 72, 74, 76, 82, 84, 90, 100,
104, 110, 115, 121, 123, 130–1.

Pietro da Cortona,
properly Pietro Berrettini
(Cortona 1596–Rome 1669),
painter and architect.
His work, characterized by
spectacular compositions in
brilliant colors, with theatrical
illusions, ranked him among
the major exponents of
Baroque art, p. 104.

**Quevedo y Villegas,
Francisco Gómez de** (Madrid
1580–Villanueva de los Infantes
1645), poet and author. A cultured
man of high intellect and deep
feeling, his thinking was dominated
by a sense of responsibility
associated with humanism.
He attempted to reconcile the
Christian spirit with historical
circumstances, while still within
a framework of bitter social
criticism, pp. 32, 33.

Reni, Guido (Bologna
1575–1642), painter. One of

the greatest interpreters
of classicism, his painting
was formal and grandiose,
reminiscent of the ancient and
Renaissance world, in contrast
to the more dramatic trends
initiated by Caravaggio,
pp. 54, 55, 57, 58.

Ribera, Jusepe de,
known as Lo Spagnoletto (Játiva
1591–Naples 1652), painter. After
travelling to Italy when young, he
trained in Rome and then later
moved to Naples. His style was
based on that of Caravaggio in

■ Guido Reni,
Aurora, 1613, Palazzo
Pallavicini Rospigliosi.

its use of tenebrism – he also aimed to reproduce reality in all its crudeness and immediacy – but in time this was toned down in his later treatment of more overtly classical and monumental themes, pp. 10, 11, 104, 113.

Rizi, Francisco (Madrid 1614–Escorial 1685), painter. Son of Antonio Ricci, the Italian artist who emigrated to Spain, and brother of Juan Andrés, he was a court painter and talented stage designer, pp. 115, 126.

Rizi, Juan Andrés (Madrid 1600–Montecassino 1681), painter and writer. His painting was

characterized by strict, vigorous naturalism, pp. 49, 126.

Rubens, Peter Paul (Siegen 1577–Antwerp 1640), painter. His artistic training was in Cologne and Antwerp, but his journey to Italy (1600–08) proved decisive: his contact with Italian art led him to develop a grandiose and eloquent style of painting that justified his being classified among the greatest masters of his time and one of the principal interpreters of the Baroque style, pp. 40, 42, 43, 84, 110, 119.

Sánchez Cotán, Fray Juan (Orgaz 1561—Granada 1627),

painter. A specialist in still life (*bodegones*), he produced works with a purity and spirituality that seemed to anticipate Zurbarán, pp. 13, 19.

Spinola, Ambrogio (Genoa 1569–Castelnuovo Scrivia 1630), soldier and politician. At the head of a small private army, he placed himself at the service of Spain and was appointed commanding general and then supreme commander of Spanish troops in the Netherlands. After the failure of the war for the succession of Mantua and Monferrato, his enemies at court ensured his rejection by the king, pp. 50, 81.

Tintoretto, properly Jacopo Robusti (Venice 1518–94), painter. His bold and expressive

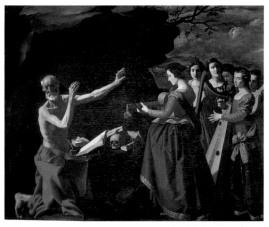

■ Zurbarán, *Temptation of St Jerome*, 1638–39, Hieronymite Monastery, Guadalupe.

paintings for many churches and societies united elements derived from the Tuscan-Roman Mannerist school and the application of brilliant colors in the Venetian tradition. His rapid technique, full of tension, had an influence on Velázquez, pp. 50, 51, 94.

Titian, Titiano Vecellio (Pieve di Cadore c.1490–Venice 1576), painter. Heir to the Venetian tradition, the expressive strength of his color and the new dynamic and plastic responses of Mannerism were the basics on which his vast artistic production was founded and subsequently evolved. His work comprised altarpieces, paintings of secular and religious subjects, and portraits. Among his clients and patrons were popes, princes of the Church, nobility, and monarchs throughout Europe, for whom he painted masterpieces that were to influence later generations

Peter Paul Rubens, Deborah Kip, Wife of Balthasar Gerbier, Her Children, –40, Andrew W. n Foundation, al Gallery of ashington.

of artists in all countries, pp. 8, 9, 37, 38, 42, 72, 83, 96, 97, 99.

Urban VIII, Maffeo Barverini (Florence 1568–Rome 1644), pope. Elected in 1623, he initiated a policy that advanced his family, amassed him wealth, and maintained the supremacy of the Church in its confrontations with the State, p. 56.

Vega, Lope de (Madrid 1562–1635), dramatist and poet. He travelled extensively throughout his eventful life, and all his experiences eventually found their way into the pages of his richly fertile literary works, which

mirrored the spirit of the nation and the age. He was extremely popular, and most of Spain mourned his death, pp. 32, 33, 112.

Zurbarán, Francisco de (Fuente de Cantos 1598–Madrid 1666), painter. His austere, dramatic style of painting was based on the use of brilliant light as a means of "revealing" reality: people and objects, assembled in a dark, indeterminate space, emerge in vivid detail, silhouetted by light. His work has a visionary and mystical message, which evokes the climate of the Counter-Reformation and Iberian religious teaching, pp. 10, 19, 22, 74, 116, 126.

A DK PUBLISHING BOOK
www.dk.com

TRANSLATOR
John Gilbert

DESIGN ASSISTANCE
Joanne Mitchell, Rowena Alsey

EDITORS
Fergus Day, Louise Candlish

MANAGING EDITOR
Anna Kruger

Series of monographs
edited by Stefano Peccatori and Stefano Zuffi

Text by Rosa Giorgi

PICTURE SOURCES
Archivio Electa, Milan
Archivio Scala, Antella
Elemond Editori Associati wishes to thank all those museums and
photographic libraries who have kindly supplied pictures, and would be pleased
to hear from copyright holders in the event of uncredited picture sources.

Project created in conjunction with
La Biblioteca editrice s.r.l., Milan

First published in the United States in 1999 by DK Publishing Inc.
95 Madison Avenue, New York, New York 10016

Velázquez, Diego, 1599–1660.
 [Velázquez. English]
 Velázquez. -- 1st American ed.
 p. cm. -- (ArtBook)
 Includes indexes.
 ISBN 0-7894-4855-6 (alk. paper)
 1. Velázquez, Diego, 1599–1660. I. Title. II. Series: ArtBook
(Dorling Kindersley Limited)
ND813.V4A4 1999
759.6--dc21 99-31208
 CIP

First published in Great Britain in 1999
by Dorling Kindersley Limited,
9 Henrietta Street, London WC2E 8PS

A CIP catalogue record of this book is available from the British Library.

ISBN 0-7513-0781-5

2 4 6 8 10 9 7 5 3 1

Printed by Elemond s.p.a. at Martellago (Venice)